Art and Technics

Art and Technics

LEWIS MUMFORD

NEW YORK AND LONDON

COLUMBIA UNIVERSITY PRESS

701
M919a

EXCEPT FOR the inevitable omission of spontaneous interpolations, these lectures now come forth in the form they were originally delivered. They were written for the speaking voice, and though this form would prove trying, no doubt, in a lengthier discourse, it seemed to me that in such brief compass as this book, the lectures would lose more than they would gain by being put into the more incisive style of written prose. I have made some slight omissions and amplifications in the lecture on architecture; but these cause no change of meaning. To those who were present at the lectures, I take this occasion to give my thanks once more for their cheerful patience and responsive participation.

L. M.

Contents

Art and Technics

Art and the Symbol

AT THE BEGINNING of a series of lectures, it is perhaps well to establish some common point of agreement between the lecturer and his audience; and to ensure this I shall begin by making a flat observation: *We live in an interesting age!* This is not quite so innocent a commonplace as you may fancy; for like the Chinese, who have lived through many periods of disorder and violence, similar to our own, I would use the word interesting in a somewhat acrid sense. We are told that when traditionally a Chinese scholar wished to utter a withering curse upon his enemy, he merely said, May you live in an interesting age! The Chinese knew that few of the good things of life could come to consummation in the midst of moral landslides and political earthquakes.

What makes our age so interesting, of course, is the number of shocking contradictions and tragic paradoxes that confront us at every turn, creating problems that tax our human capacities for understanding, releasing

forces we lack the confidence to control. We have seen starvation in the midst of plenty, as millions of desolate people in India still see it: we have seen the heartfelt renunciation of war, which followed the First World War, leading to the enthronement of military dictatorships: we are even now seeing the hatred of totalitarianism producing, in our own constitutional republic, many of the most repulsive features of totalitarianism, including the hysterical worship of a military leader. And so it has been with many other apparent blessings. Certainly Art and Technics, the subject of the present lectures, have not escaped these contradictions.

Three and a half centuries ago Francis Bacon hailed the advancement of scientific learning and mechanical invention as the surest means of relieving man's estate: with a few expiatory gestures of piety, he turned his back upon religion and philosophy and art and pinned every hope for human improvement on the development of mechanical invention. He met his death, indeed, not after writing a series of final aphorisms about the conduct of life, but after exposing himself to the elements in one of the first experiments in the use of ice for preserving food. Neither Bacon nor his eager followers in science and technics, the Newtons and Faradays, the Watts and the Whitneys, had any anticipation of the fact that all our hard-won mastery of the physical world might, in the twentieth century, threaten the very existence of the human race. If by some clairvoyance Bacon could have followed to their ultimate conclusions the developments he forecast with such unqualified optimism, he might easily have decided, instead of continuing his speculations in science, to write Shakespeare's plays, as at least

a more innocent occupation. Bacon did not foresee that the humanization of the machine might have the paradoxical effect of mechanizing humanity; and that at this fatal moment the other arts, once so nourishing to man's humanity and spirituality, would become equally arid, and so incapable of acting as a counterpoise to this one-sided technical development.

None of these tendencies, we must be thankful, has yet been carried to its ultimate conclusion: this is still 1951, not yet "1984." But in a recent book, which should have been more widely discussed and pondered than it actually was, Mr. Roderick Seidenberg made a canvass of the tendencies toward mechanical organization and automatism that have been displacing man from the center of the stage, and reducing him to a mere shadow of the machine he had created; and it is very plain from his analysis that if the present forces are not controlled and redirected, the end is in sight, and a new creature, called by Mr. Seidenberg "Post-Historic Man"—this is the title, too, of his book—will occupy the stage, or rather, will merge himself with the props and backdrops and lighting fixtures, indistinguishable, so to speak, from the scenery.

If that fate were the only one open to us, the human race, in a final effort at its own self-preservation, might have to take to heart Samuel Butler's suggestion, in *Erewhon,* and not merely destroy all our old machines, but severely penalize any effort to make new ones. Neither of these alternatives, plainly, should be accepted until we have at least made a bold effort to bring together the mechanical and the personal, the objective and the subjective sides of our life, in order to establish them once more in an organic working relationship. But before

we shall have the energy to make such an effort, we must show a better understanding than most of us have yet shown of the nature of our present predicament.

During the last two centuries there has been a vast expansion of the material means of living throughout the world. But instead of our thus producing a state of widely distributed leisure, favorable to the cultivation of the inner life and the production and enjoyments of the arts, we find ourselves more absorbed than ever in the process of mechanization. Even a large part of our fantasies are no longer self-begotten: they have no reality, no viability, until they are harnessed to the machine, and without the aid of the radio and television they would hardly have the energy to maintain their existence. Compare our present situation with that which accompanied the relatively technical primitive era of the seventeenth century. In that time a good London burgher, like Samuel Pepys, a practical man, a hard-working administrator, would select the servants in his household partly on the basis of their having a good voice, so that they might sit down with the family in the evening to take part in domestic singing. Such people not merely listened passively to music, but could produce it, or at least reproduce it, in their own right. Today, in contrast, we often see people wandering around with a portable radio set on Riverside Drive, listening to a radio musical program, with no thought that they might sing a song freely in the open air without invoking any mechanical aid.

Even worse, the very growth of mechanical facilities has given people a false ideal of technical perfectionism, so that unless they can compete with the products of the machine or with those whose professional training quali-

fies them for such a public appearance, they are all too
ready to take a back seat. And, to complete this process,
not in the least to offset it, in those special realms of art,
above all painting, that once recorded the greatest free-
dom and creativeness, we find that the symbols that most
deeply express the emotions and feelings of our age are
a succession of dehumanized nightmares, transposing
into esthetic form either the horror and violence or the
vacuity and despair of our time. Undoubtedly one of the
great paintings of our day is Picasso's Guernica mural,
just as he himself is one of the great artists of our time,
with a capacity for beautiful rhythmic expression like
that of a dancer; a gift that the stroboscopic camera has
recently revealed. But the fresh symbols that come forth
from his masterly hand reveal chiefly the wounds and
scars of our time, with not even the faintest hint of a new
integration. At times, as in the preliminary sketches for
the Guernica mural, the emotion is so lacerating that the
next step beyond would be either insanity or suicide.

Violence and nihilism: the death of the human per-
sonality. This is the message that modern art brings to
us in its freest and purest moments; and that, obviously,
is no counterpoise to the dehumanization wrought by
technics.

Most of the great artists of the last two centuries—and
this has been equally true, I think, in music and poetry
and painting, even in some degree in architecture—have
been in revolt against the machine and have proclaimed
the autonomy of the human spirit: its autonomy, its
spontaneity, its inexhaustible creativeness. Actually, the
religious impulse, suppressed by the institutionalism of
the Churches, manifested itself during this period chiefly

in the arts, so that the great saints of the last century were as often as not artists, like Van Gogh or Ryder or Tolstoy. This strong reaction against a too-singleminded commitment to mechanical invention and practical effort helped produce great works of music and painting, perhaps as great as any other age could show. In the great symphonic music of the nineteenth century the human spirit utilized its characteristic division of labor, its specialization of functions, and its intricate organization of time and rhythm to express the tragic yearnings and joyful triumphs of this new epoch. Because of the traditional separation of art and technics we have yet sufficiently to realize that the symphony orchestra is a triumph of engineering, and that its products, such as the music of Mozart and Beethoven, etherealized into symbols, will probably outlast all our steel bridges and automatic machines.

But that protest was possible, those triumphs could be expressed, only so long as a belief in the human person, and particularly in the inner life, the creative moment, remained dominant, carried over from the older cultures that had nourished the human spirit. By the end of the nineteenth century, this evocative protest began to die away. In a mood of submission and self-abnegation, sensitively recorded by Henry Adams, people began to worship the machine and its masters. If anyone was *un*real, Adams wrote, it was the poet, not the businessman. We had created a topsyturvy world in which machines had become autonomous and men had become servile and mechanical: that is, thing-conditioned, externalized, de-humanized—disconnected from their historic values and purposes. And so it has come about that

one whole part of man's life, springing from his inner-most nature, his deepest desires and impulses, his ability to enjoy and bestow love, to give life to and receive life from his fellow men, has been suppressed. Those deep organic impulses for which art is both the surrogate in immediate action and the ultimate expression of that action as transferred to the life of other men—all this part of man's nature has become progressively empty and meaningless. The maimed fantasies, the organized frustrations, that we see in every comprehensive exhibition of modern painting today are so many symptoms of this deep personal abdication. Pattern and purpose have progressively disappeared, along with the person who once, in his own right, embodied them. Man has become an exile in this mechanical world: or rather, even worse, he has become a Displaced Person.

On one hand, through the advance of technics, we have produced a new kind of environment and a highly organized routine of life, which satisfies, to a fabulous degree, man's need to live in an orderly and predictable world. There is something noble, as Emerson recognized long ago, in the fact that our railroads, our ocean steam-ships, our planes, run on a time-schedule almost as regular as the movement of the heavenly bodies. Uniformity, regularity, mechanical accuracy and reliability all have been advanced to a singular degree of perfection. And just as the autonomic nervous system and the reflexes in the human body free the mind for its higher functions, so this new kind of mechanical order should bring about a similar freedom, a similar release of energy for the creative processes. Because of our achievement of me-chanical order throughout the planet, the dream of Isaiah

might in fact come true: the dream of a universal society in which men shall be weaned from habits of hostility and war. Originally these aggressions were perhaps the natural outcome of anxiety for the future, in periods when there was never enough food or goods to go round: periods when only the powerful could arrogate to themselves all the resources men needed to be fully human.

But the good fairy who presided over the development of technics did not succeed in forestalling the curse that accompanied this genuine gift: a curse that came from this very overcommitment to the external, the quantitative, the measurable, the external. For our inner life has become impoverished: as in our factories, so throughout our society, the automatic machine tends to replace the person and to make all his decisions—while, for its smoother working, it anesthetizes every part of the personality that will not easily conform to its mechanical needs.

All these are the veriest commonplaces of our "interesting age"; I remind you only of what you already know. On one side, the highest degree of scientific and technical refinement, as in the atomic bomb; on the other side, moral depravity, as in the use of that bomb not to conquer armies, but to exterminate defenseless people at random. On one side, intellectual maturity, as in the cooperative activities of science; on the other, crass emotional immaturity—the kind painfully exhibited by the traitorous physicist Fuchs. External order: internal chaos. External progress: internal regression. External rationalism: internal irrationality. In this impersonal and overdisciplined machine civilization, so proud of its objectivity, spontaneity too often takes the form of criminal

acts, and creativeness finds its main open outlet in destruction. If this seems like an exaggeration, that is due only to the illusion of security. Open your eyes and look around you!

Now I put these paradoxes and contradictions before you at the beginning, dismaying though they may be, because I believe that the relations between art and technics give us a significant clue to every other type of activity, and may even provide an understanding of the way to integration. The great problem of our time is to restore modern man's balance and wholeness: to give him the capacity to command the machines he has created instead of becoming their helpless accomplice and passive victim; to bring back, into the very heart of our culture, that respect for the essential attributes of personality, its creativity and autonomy, which Western man lost at the moment he displaced his own life in order to concentrate on the improvement of the machine. In short, the problem of our time is how to prevent ourselves from committing suicide, precisely at the height and climax of our one-sided mechanical triumphs.

There are doubtless many other excellent reasons for studying the relation of art and technics; and in a happier period of history I might have been tempted to dwell on them more extensively than I propose to do in the present lectures. By now, however, every intelligent observer knows—as Mr. Arnold Toynbee, among others, has impressively demonstrated—that our civilization cannot go on indefinitely in the present fashion. Like a drunken locomotive engineer on a streamlined train, plunging through the darkness at a hundred miles an hour, we have been going past the danger signals with-

out realizing that our speed, which springs from our
mechanical facility, only increases our danger and will
make more fatal the crash. If we are to find a different
destination for our civilization, every part of our life must
be re-examined and overhauled, every activity must
undergo criticism and revaluation; every institution must
seek its own renovation and renewal. Precisely in those
areas where modern man has seemed most prosperous
and secure, most efficient in action, most adept in
thought, we begin to realize that something has been
left out of his regimen, something essential to his organic
balance and development.

What is that missing element? That missing element,
I suggest, is the human person. Our power and knowl-
edge, our scientific discoveries and our technical achieve-
ments, have all been running wild because Western man
turned his back upon the very core and center of his own
life. He has not merely lost confidence in himself: he has
made his proper life insignificant, and so he finds the rest
of the world equally empty of values, equally insignifi-
cant. More and more, from the sixteenth century on,
modern man patterned himself upon the machine. De-
spite sentimental compunctions of various sorts, com-
punctions expressed in the romantic movement, in na-
tionalism, in the reactivation of Christian theology,
Western man has sought to live in a nonhistoric and im-
personal world of matter and motion, a world with no
values except the value of quantities; a world of causal
sequences, not human purposes. Even when he has
added depth to his life by his exploration of the human
soul, as Sigmund Freud and his followers undoubtedly
have done in psychology, he has used his new-found

knowledge to a large degree only to continue the general process of self-devaluation.

In such a world, man's spiritual life is limited to that part of it which directly or indirectly serves science and technics: all other interests and activities of the person are suppressed as "non-objective," emotional, and therefore unreal. This decision in effect banished art, because art is one of the essential spheres of man's autonomous and creative activities. Art as the domain of symbol and form, of pattern and significance became the blighted area of modern life, within whose dilapidated mansions a few pious caretakers and family servants fought a hopeless battle against neglect and the final abandonment of the deserted homes themselves. That is why, with all our boasted efficiency of machines, with all our super-abundance of energy, food, materials, products, there has been no commensurate improvement in the quality of our daily existence; why the great mass of comfortable well-fed people in our civilization live lives of emotional apathy and mental torpor, of dull passivity and enfeebled desire—lives that belie the real potentialities of modern culture. *Art degraded, imagination denied, war governed the nations.* Thus spoke William Blake; and we have lived to understand the truth of that aphorism.

My special purpose in these lectures, then, springs out of our common responsibility to restore order and value and purpose, on the widest scale, to human life. This means two things. We must find out how to make our subjective life more disciplined and resolute, endowed with more of the qualities that we have poured into the machine, so that we shall not equate our subjectivity with the trivial and the idle, the disorderly and

the irrational, as if the only road to free creativity lay
through a complete withdrawal from the effort to com-
municate and cooperate with other men. When society
is healthy, the artist reinforces its health; but when it is
ailing, he likewise reinforces its ailments. This is proba-
bly the reason that the artists and the poets are looked
upon with suspicion by moralists like Plato or Tolstoy,
who write in a time of decay. Though the esthetic move-
ments of our time—post-impressionism, futurism, cub-
ism, primitivism, surrealism—have taught us much
about the actual nature of our civilization, they them-
selves, from this point of view, are so conditioned by the
very disintegration they draw upon for nourishment that
they are incapable, without themselves undergoing a
profound spiritual change, of bringing a new balance
and security into our life.

Fortunately, here and there, one still finds truly inte-
grated artists. Survivors of a better past, precursors of a
better future can in fact be found: people like Naum
Gabo in sculpture and Frank Lloyd Wright in architec-
ture; artists whose work begins once more to have fresh
meaning for the younger generation. But if our life as a
whole is to take on the qualities foreshadowed in the
work of these artists, the world of technics itself must be
transformed: salvation lies, not in the pragmatic adapta-
tion of the human personality to the machine, but in the
readaptation of the machine, itself a product of life's
needs for order and organization, to the human person-
ality. A human pattern, a human measure, a human
tempo, above all, a human goal must transform the activi-
ties and processes of technics, curbing them, when they
become dangerous to man's development, even cutting

them off for a while—as a more prudent world statesmanship would have cut off our present developments of atomic energy—until the appropriate political instruments and social institutions had been created for directing technics into the channels of human development. If our civilization is not to go further in the disintegration now manifested in the state of art and technics, we must salvage and redeem the Displaced Person; and that means that we must pour once more into the arts some of the vitality and energy now almost wholly drained off by a depersonalized technics.

Already, by my use of the terms art and technics, I have partly defined them; but now let me make their definition a little more precise. Technics is a word that has only lately come into use in English; people still sometimes try to Frenchify it into "techniques" and thereby give it a quite different meaning. We ordinarily use the word technology to describe both the field of the practical arts and the systematic study of their operations and products. For the sake of clarity, I prefer to use technics alone to describe the field itself, that part of human activity wherein, by an energetic organization of the process of work, man controls and directs the forces of nature for his own purposes.

Technics began when man first used his fingers for pincers or a stone for a projectile: like art itself, it is rooted in man's use of his own body. But man has gone on developing his technical facilities, slowly, fitfully, only rarely in such rapid spurts as we have seen during the last century; so that by now he has extended the range and power of many of his organic aptitudes: he can kill at a distance of five thousand yards and converse at a

distance of five thousand miles; and in certain compli-
cated mathematical calculations he can, by the aid of
an electronic brain, perform in a few seconds operations
that might otherwise take a lifetime of strenuous effort.
All these magnified human powers are the result of hu-
man desires, human contrivances, human efforts. How-
ever formidably automatic the machine may look, there
is always a man lurking in the background, adjusting it,
correcting it, nursing it; and the machine itself is half
slave, half god. You might in fact call the machine
modern man's totem animal.

Art, in the only sense in which one can separate art
from technics, is primarily the domain of the person; and
the purpose of art, apart from various incidental techni-
cal functions that may be associated with it, is to widen
the province of personality, so that feelings, emotions,
attitudes, and values, in the special individualized form
in which they happen in one particular person, in one
particular culture, can be transmitted with all their force
and meaning to other persons or to other cultures. Sym-
pathy and empathy are the characteristic ways of art: a
feeling with, a feeling into, the innermost experiences of
other men. The work of art is the visible, potable spring
from which men share the deep underground sources of
their experience. Art arises out of man's need to create
for himself, beyond any requirement for mere animal
survival, a meaningful and valuable world: his need to
dwell on, to intensify, and to project in more permanent
forms those precious parts of his experience that would
otherwise slip too quickly out of his grasp, or sink too
deeply into his unconscious to be retrieved.

Because of their origin and purpose, the meanings of

art are of a different order from the operational meanings
of science and technics: they relate, not to external means
and consequences, but to internal transformations, and
unless it produce these internal transformations the work
of art is either perfunctory or dead. Man's technical con-
trivances have their parallel in organic activities ex-
hibited by other living creatures: bees build hives on
engineering principles, the electric eel can produce elec-
tric shocks at high voltage, the bat developed its own
form of radar for night flight long before man. But the
arts represent a specifically human need, and they rest
on a trait quite unique in man: the capacity for symbol-
ism. Unlike animals, man not merely can respond to
visible or audible signals; he is also able to abstract and
re-present parts of his environment, parts of his experi-
ence, parts of himself, in the detachable and durable
form of symbols. With the sounds that come forth from
his mouth in childish babble, with the images that haunt
him, detached from the visible world, both by night and
by day, eventually with many other different kinds of
sounds and images and forms and structures, man found
the means of internalizing the external world and of ex-
ternalizing his internal world. Long before man had
achieved any degree of causal insight or rational order,
long before he had conceived of the operation of imper-
sonal forces, he had developed in the arts a special means
of perpetuating, of recalling, of sharing with others his
own essential experience of life. Even today it is not
without significance, perhaps, that an infant develops
recognizable gestures and begins to babble and use iden-
tifiable word-sounds, usually before he begins to crawl
or walk: the function of communication precedes the

function of work, and is of immensely greater significance for the development of human society.

The greatest of man's symbolic functions is of course speech; but speech, as the Danish philologist Otto Jespersen pointed out, was probably a source of emotional communion long before it became a useful instrument of practical communication. By tone and rhythm, by poetic and musical qualities, words became a special bond between mother and child, or between lovers who needed an extra outlet for their enchantment and ecstasy. Whatever primitive man may have been, he surely was not a logical positivist. Essentially the symbolic functions begin as expressions of inner states, as an externalization and projection of attitudes and desires, sometimes in response to inner promptings, sometimes in response to the external world and its inhabitants. By the feat of symbolic representation, man freed himself from the pressing suggestions of his immediate environment, from a limited here and now. He not merely found a way of creating circuitous responses which enabled him to enlist other aspects of his life than those aroused by the immediate situation. He not merely found a way to recombine past experiences in a single symbolic representation, but what is perhaps even more characteristically human, he was able to project new potentialities for life, new experiences, which as yet had no objective existence. Art at its best discloses heretofore hidden meanings. It tells more than the eye sees or the ear hears or the mind knows. With the aid of the symbol man not merely united time past with time present, but time present with ideal possibilities still to emerge in the future. With the aid of the symbol, man not merely remembered the vanished

past: he took in the emergent or the potential future. Be-
ginning in dream, word, gesture, man attempts to estab-
lish a personal relationship, an I-and-Thou relationship
with every other dimension of his experience. This "say-
ing" is as important for man's spiritual development as
"doing" is for his physical subsistence. Without the sym-
bols of art, in all their many manifestations—painting
and music, costume and architecture, poetry and sculp-
ture—man would live culturally in a world of the deaf,
the dumb, and the blind. It is only at a very late stage
of history that the symbol becomes useful as a device of
abstract thought, in the service of science and eventually
of technics. The mythic and poetic functions of the sym-
bol, as Vico long ago correctly pointed out, antedated its
rational and practical uses.

Do not misunderstand me here. Not all symbolism, of
course, is art. Once man had given an independent form
to sounds and images, using them not merely for intimate
communion but for specific factual communication, he
was too intelligent not to grasp their immense practical
importance in every transaction of daily life. By means
of symbols, man was able to escape from the clumsy con-
creteness, the overwhelming multiplicity, of the im-
mediate world. The human mind functions symbolically,
as the philosopher Alfred North Whitehead put it,
"When some components of its experience elicit con-
sciousness, beliefs, emotions, and usages respecting other
components of its experience." That is an admirable defi-
nition of the symbolic function in general; and I would
qualify it only by adding that the components that per-
form these functions are necessarily logical abstractions
or esthetic condensations of the immediate experience.

Otherwise every symbol would have to be as large as life and therefore indistinguishable from the original experience. In other words, mere substitution without abstraction would be as boring as the habit of total recall in telling a story—and more futile.

Art, it follows, in all but its most trivial and imitative forms, is not a substitute for life or an escape from life: it is a manifestation of significant impulses and values that can come forth in no other way. Even in the oldest paleolithic cave painting, the artist reveals more to us than the fact that he had observed the bison carefully, or that he venerated it as a totem animal: he also reveals, in the very quality of his line—in its selectivity, its sureness, its expressive rhythm—something even more essential about the nature of his own experience and culture. And if a dozen anthropologists had been observing and recording his life, they could not tell us more: indeed, in certain ways—the artist's "secret"—they could not tell us half as much. Or suppose we look at three nudes by Cranach, Rubens, and Manet: the virginal wife of the Middle Ages, the lusty bed fellow and willing mother of the Renascence, the cold, almost boyish courtesan of the nineteenth century. We find, in these condensed esthetic forms, three different ways of looking at the world, three different kinds of personality, three different philosophies: three cultures, not just three women. Art uses a minimum of concrete material to express a maximum of meaning. And if what we read into a Rorschach ink blot reveals our innermost nature, what do we not find and disclose about ourselves in the complex and deliberately evocative symbols of art?

We might say further, then, to differentiate between

art and technics, that art is that part of technics which bears the fullest imprint of the human personality; technics is that manifestation of art from which a large part of the human personality has been excluded, in order to further the mechanical process. No matter how abstract art is—and even in the most realistic convention every work of art is an abstraction—it can never be entirely impersonal or entirely meaningless. When art seems to be empty of meaning, as no doubt some of the abstract painting of our own day actually does seem, what the painting says, indeed what the artist is shrieking at the top of his voice, is that life has become empty of all rational content or coherence. And that, in times like these, is far from a meaningless statement.

Though the world we live in is constantly modified by our use of symbols, it has taken us a long time to notice the way in which symbols mediate all experiences above the level of our animal reflexes. Since the time of David Hume we have tended to take for granted that our sense-data, rather than our symbols, form the solid groundwork of experience. But the brilliant researches of Adelbert Ames have experimentally established the fact that sensations are no more primary than any other element in experience: that they do not impinge upon us directly, but are always being linked up with the meanings and values and purposes of the organism, as established either in the general plan of life of the species, or in man's particular interests and needs, conditioned as they are by his history and culture. Once we recognize the part played generally by the symbol, in subjectifying and personalizing the world, we can understand the limitations of science and technics, since they are by intention

an expression of that part of the personality from which emotion and feeling and desire and sympathy—the stuff of both life and art—have been eliminated.

Strangely, it is only in our own day that the work of George Mead, Ernst Cassirer, W. M. Urban, and Suzanne Langer in philosophy has drawn attention to the constant part played by man's propensity to symbolize his experience; and in particular to the dynamic role of the esthetic symbol, in revealing man's nature and further modifying it. Our long neglect of the symbol, like our complete withdrawal of interest from the dream, was due perhaps to a cultural change that took place in the eighteenth century, through the naive rationalism and practical enthusiasm of the *philosophes,* led by Diderot. In his biography of Diderot, indeed, John Morley suggested that our devaluation of symbols was perhaps part of a more general shift in the intellectual climate: a turning away from an interest in words to an interest in things, from matters of value to matters of fact. This movement both resulted from the advances of technics and gave further encouragement to those advances; but, though it was hailed as a great emancipation of the spirit, we can now see that it actually involved a displacement of the rest of the personality, and a disparagement of a good half of human life—that which has its source, not in external conditions and forces, but in the inner nature and historic values of man. In correcting this one-sided development we must not make the mistake of attempting to repress the impersonal, the practical, the technical; we should rather seek to bring these activities into working unity with other parts of the personality. As we shall see in the next lecture, they have an important contribu-

tion to make, once they cease to exercise a one-sided dominion.

Now, one does not have to be a follower of Benedetto Croce to see that all art is fundamentally expression: not expression in general, but expression by means of esthetic symbols. Art stands as visible sign of an indwelling state of grace and harmony, of exquisite perception and heightened feeling, focused and intensified by the very form into which the artist translates his inner state. This kind of expression is fundamental to man's own sense of himself: it is both self-knowledge and self-realization. Historically, art comes into existence not as an afterthought, in the way that the industrial magnates of an older generation imported art into their communities after they had built their factories and steel mills and made their pile. Just the contrary, art arises at the very beginning of man's specifically human, his superanimal, development. Though this is only a speculation, supported by analogy, the most elemental form of art is probably body decoration, an art that remains today the most universally practiced of all the arts. By this means, primitive man probably sought to lift himself out of his generic animal state, if only by smearing yellow or red clay over his face: he thus attempted to identify himself and his group, to externalize himself in a new form, to visualize himself in a fashion that set him off from his animal condition.

We derive the very word person from the Latin word for mask, and body decoration was the first of man's efforts to mask his animal propensities and to achieve, and make visible, a different self. That earliest expression was perhaps more communal than personal. But as man

developed both in self-confidence and in skill, he sought
to differentiate himself and to project himself in other
forms than his own body. With the development of
language in general, that marvelous structure for com-
munion and communication added immensely both to
the domain of the symbol and the province of the self;
so that in time everything man touched—not merely his
body, but his tools and utensils, his clothes and gear, his
houses and his temples and his cities—was wrought in
some degree in his own image, and passed on to other
men his feelings and thoughts, about himself, about na-
ture, about the cosmic processes. The development of
technics itself aided this expression. Did it not take a
hundred thousand slaves and immense technical skill to
make visible, in the Pyramids, the Egyptian notion of
eternity? But for long the technical instrument lagged
behind the symbol in its development.

In the course of history, art has taken many forms and
said many things. But in contrast to technics, which is
mainly concerned with the enlargements of human
power, art is essentially an expression of love, in all its
many forms from the erotic to the social. Do not think
that I purpose to bore you by once more tracing art
back to its most infantile oral and anal manifestations;
though there is no reason why we should reject whatever
measure of truth there may be in this Freudian analysis.
I would begin rather with the simpler facts of common
experience, which psychological analysis has only con-
firmed for us: namely, that the development of art his-
torically has its parallel in the development of the in-
dividual, and that human infants exhibit, without em-
barrassment, many characteristics we find most marked

in the artist—above all a certain innocent self-love, which makes him regard his own productions as precious and worthy of attention. Without that fundamental vanity, man might never have had sufficient respect for the materials of symbolism to transform them into works of art—works taking stable form under an exacting discipline, and so capable of influencing the feelings and conduct of other men.

There are, as I see it, three stages in the development of art. Let us pause to examine them a little more closely. I should call them first, the self-enclosed or infantile stage, the stage of self-identification; second, the social or adolescent stage, when exhibitionism passes into communication, with an effort not merely to attract attention but to create something worthy of approval; and finally, a personal or mature stage, when art, transcending the immediate needs of the person or the community, becomes capable of begetting fresh forms of life: when the work of art becomes itself an independent force, directly energizing and renewing those who come into contact with it, even though they may be separated by time and space from the original culture, now vanished, or the original person, now dead. At this final stage, the highest degree of individuation produces the widest range of universality.

Let us follow these stages of maturation. Every person, to begin with, is an object of naive interest to himself: at first, in infancy, he lives almost wholly immersed in his own world, gurgling and babbling, moving and gesturing, full of wonder at all the potentialities for expression he finds in his own organs. This self-preoccupation, I repeat, is a fundamental ingredient in art; and

the sense of self-importance that goes with it expresses itself very early in one of the child's earliest commands: *Look at me!* Presently a child finds that he has a better chance of being obeyed if he can, by some grimace or posture, by some cuteness or sweetness, persuade his elders to enter into the game: even bears, monkeys and seals at the zoo advance so far on the road to art. The more lovable a child is or the more beautiful he is in his own person, the easier he finds it to gain attention without simply making a nuisance of himself; and that early lesson in form is underlined by social experience. With the growth of consciousness the demand, "Look at me!" becomes more complicated: in time it means, Look at what is peculiar in me, what is precious in me, what makes me different from every other creature in the world. The individuated, the personal, the nonrepeatable, these are essential characteristics of the esthetic symbol. Perhaps this explains, incidentally, why a perfect forgery in art does not, once we have found the fraud out, please us as much as a relatively poor original.

The second stage of art goes beyond this primitive expressionism and self-identification, indeed self-glorification. After "Look at me!" comes an invitation: *I have something to show you!* Now it is not enough to shout or grimace or shock in order to gain attention; and the artist is no longer content just to satisfy his own vanity. Even Narcissus needs a mirror: and the best mirror, better than any pool or looking glass, however objective its reflection, is another pair of responsive human eyes. Beginning with the artist's self-love, the work of art now becomes a special bond of union. At some very early stage in his development as artist, man discovers

the fact that works of art must have attributes of form
and proportion and organization similar to—though
surely not identical with—those that attract him in nat-
ural forms. To gain more than passing attention, the
work of art must take on such organic character.

Here again there is a parallel in childhood. A very little
child, after he has gained your attention, will sometimes
show you a stone or a dead fly, in an effort to hold your
interest; but if he shows you a scrawl on paper he has a
better chance of keeping your interest; and, if his draw-
ing shows even a hint of good rhythm or color, he will
bring forth even more positive enthusiasm. This brings
us to the second characteristic of works of art: they do
not hold one long if they are merely insistent or merely
shocking; they must also be captivating, and, in some
not too blatant way, significant. And yet that signifi-
cance must not be too obvious and definite, like a numer-
ical sign, which says precisely what it means. On the
contrary, it must be a little ambiguous, a little myste-
rious; it must leave play for an answering response, of
an equally indeterminable kind, in the spectator or lis-
tener, who thus participates in the creative act.

Not the least peculiarity of art is that it must be
capable of stirring hidden depths in the beholder, mak-
ing him conscious, through his reading of the artist's
secret, of a similar secret in his own bosom; just as the
virgin, awakened by the first approaches of a lover, be-
comes conscious of hidden longings and ardors that had
hitherto been locked up—or had been attached to cold
instructions on the topography and geology of the sexual
organs, in dull books entitled "How to be Happy though
Adolescent." This second stage in art involves more than

self-disclosure: it involves courtship. And at that stage,
the artist's gift, his very development, depends upon
the existence of a responsive audience, of people not too
busy to listen, not so preoccupied with getting and
spending that they treat as contemptible or negligible
what the artist has to give, above all, not too tired or
bored to make the effort of understanding him. Though
the true artist paints or writes or composes what he must,
and only secondarily to please his contemporaries, he is
furthered in that effort by their interest, their pleasure,
their intuitive response—and may lose the very incentive
to creation for lack of this response. What my friend
Matthew Nowicki used to say about architecture—that
a great client was essential in the production of a great
building—holds for every other form of art; though there
have been times when the artist has had to create in
fantasy those who would at some later day understand
him. This second stage marks the passage from exhibi-
tionism to communication, from the sensational to the
emotionally significant and sharable.

But there is a third stage in the development of art:
this is the transition from self-love and exhibitionism,
from technical virtuosity and courtship, to mature love,
capable of giving and taking, of capturing and surrender-
ing, of forming a union that will bring forth a new life.
In the third stage, the artist says, through his symbols:
Whatever I have shall be yours; whatever life has given
me I shall put at your feet, not for any ulterior reward,
but because I love you and wish to serve you. I have
nothing to hide: you shall know the worst as well as the
best, and through art bless both sides of life. Let us share
this gift together; and with your help, it will live and

grow. This is the stage of full maturity, the stage that only great art reaches, for in both the artist and his community it demands a certain dedication, indeed a certain sacrifice, that sets it off from the more decorative and pleasurable phases of art. At this stage, the esthetic symbol becomes detached from the immediate life of the artist; after draining to the utmost his vitality, it starts, as it were, on an independent career of its own; or perhaps it would be truer to say that the artist's self dissolves into the work of art and transcends the limitations of his personality and culture. When art rises to this stage, the artist feels himself the instrument and agent of a higher force: the final triumph of the person is to lose himself in this act. That is the moment of mature and fruitful love, when with his whole person the artist embraces life as a whole and embodies it in symbols that reconcile its tragic contradictions and release its fullest potentialities.

As you have doubtless noticed, these three stages are a sort of paradigm of sexual love itself; and like sexual love, this development likewise brings with it the same danger of premature arrest or fixation at one of its infantile or adolescent phases, the same difficulty of making the passage from untroubled spontaneity and reckless delight to the full responsibility of a durable sexual union, with all the duties involved in begetting and nurturing offspring. Our society, because it has recklessly overdeveloped both the technics of power and the power of technics, shows many signs of these arrests and these rejections; and the result has been damaging to the arts. Because the very division of labor, with its magnification of the specialist, is hostile to the needs of

the whole personality, our society makes life difficult
for those who would in any way alter its routine to
further such development: so it turns aside, with a dis-
dainful smile, from the artist's secret. Thus, by our own
preoccupations with the practical, we condemn the
artist, if he seeks to gain attention, to sheer exhibitionism,
or at worst, to committing a nuisance, just to attract some
small modicum of attention. The Salvador Dalis and the
Ezra Pounds are obvious examples of artists who use
infantile means to recapture the normal status of the
artist in a balanced society. And just because our world
is now unwilling to meet the artist half way, it either
forces him to make his secret more impenetrable, causing
him to invent a private language, even a private my-
thology, like that of William Blake or James Joyce, to
hide his lack of auditors; or its rejection has the effect of
turning his love into hate. In that mood, the artist spoils
the possibility of union by committing, symbolically,
acts of sadistic violence, defying his fellows to have any-
thing to do with him: deforming and dismembering the
very body of love, in revenge for his rejection. At this
point even the artist's original narcissism becomes nega-
tive: instead of self-love there is self-rejection and what
is worse, self-hatred. What the esthetic symbols then
say, more plainly than downright words, is: "I hate my-
self; I hate the world; I hate you. *Drop dead!*" Or in the
still more significant curse of current slang, the artist now
says something even more sadistic and more sinister:
Don't die: suffer! When life has driven the artist to that
point of desperation, such value as the work of art
possesses is but a medicinal one for the artist; beyond

that there lies only manic violence or blank self-destruction.

You will forgive me, I hope, for dwelling so often on these negative aspects of modern art; but it is sometimes only by understanding the nature of morbid phenomena that one can define the more obvious aspects of health, sanity, balance. As I have sought to interpret it here, art is one of the primary ways in which man has cultivated his own humanness: in which he has developed his sensitiveness, in which he has established rich emotional ties, by means of symbols, with his fellow men, in which he has revealed his constant need for love, first in falling in love with himself and his own organs of expression, and then, through a long process of maturation, reaching the stage of deep communion and unreserved communication, that state which widens into a unity and self-surrender similar to that of erotic love. If art has this essential function in life, it is no accident perhaps that an age that has disregarded art and cast the artist aside, having no use for him except as a vehicle of advertisement or propaganda, it is no accident that this age has also descended close to the level of barbarism in other departments. Nor is it strange that the artist has been driven, almost in self-defense, to cultivate his *in*humanity, or to ally himself with that part of our life, the practical and the technical, which has come to serve as a sterile substitute for the more vital processes and relations. These results follow from our bias.

Let me sum up. Art and technics both represent formative aspects of the human organism. Art stands for the inner and subjective side of man; all its symbolic struc-

tures are so many efforts to invent a vocabulary and a
language by which man became able to externalize and
project his inner states, and most particularly, give a
concrete and public form to his emotions, his feelings,
his intuitions of the meanings and values of life. Tech-
nics, on the contrary, develop mainly out of the neces-
sity to meet and master the external conditions of life,
to control the forces of nature and to expand the power
and mechanical efficiency of man's own natural organs,
on their practical and operational side. Though technics
and art have at various periods been in a state of effec-
tive unity—so that the fifth century Greeks, for example,
used the word technics to apply both to fine art and
utilitarian practice, to sculpture and stonecutting—to-
day these two sides of culture have split wide apart.
Technics is steadily becoming more automatic, more
impersonal, more "objective"; while art, in reaction,
shows signs of becoming more neurotic and self-
destructive, regressing into primitive or infantile sym-
bolism, to babble and mud pies and formless scrawls.
My purpose in these lectures is to bring these two sides
of life into working relationship once more. And so,
in my second lecture, I shall attempt to do equal justice
to the Tool and the Object.

The Tool and the Object

MY FIRST LECTURE WAS, if you reflect upon it, essentially another Shelleyan Defense of Poetry: an attempt to vindicate the function of art, in the face of an age that has committed itself, massively and one-sidedly, to the conquests of technics. I distinguished art from technics mainly by emphasizing that art springs spontaneously, even in infancy, from the desire for individuation and self-expression—a desire that needs for its fullest satisfaction the warm-hearted attention and loving cooperation of others. In such fashion art becomes a vehicle for transmitting a multitude of funded values and meanings that spring from the very depths of the self. And though the symbols that art uses for its effective expression are at first just detachable sounds and images and dreams, they are built up, in the course of time, into great symbolic structures which reveal and enhance every dimension of human experience—extending man's memory, deepening his sense impressions, rousing his hopes, making

more sensitive his feelings, widening the range of sympathy and understanding and loving reciprocity with his fellow creatures. If this is a sound view of art, then a civilization that attempts to put art to one side or to make it a mere servant of practical needs—in the way that art is now used for advertisement—is actually setting aside and degrading an essential part of the nature of man.

Now the devaluation of the esthetic symbol and the dismissal of man's subjective world have gone hand in hand. The world our operationally minded contemporaries prefer to live in is one from which feeling and emotion have been deliberately eliminated: a world in which whatever seems obscure and inward, whatever cannot be reduced to a quantity, is thereby treated as unreal; a world that is, as we say, impersonal, concerned with means and consequences, not with ends and purposes. As you know, the highest praise one can give a colleague in academic circles is to say that he is thoroughly objective—which too often means in fact either that he has no feelings or impulses or desires of his own, or that he habitually sits on them. In order to justify this very limited kind of objectivity, which treats as nonexistent the subjective fish that cannot be caught in its coarse conceptual net, we moderns have taken over an old fable about man's nature and history.

One may call this fable the Promethean myth, for it begins with the assumption that man is a tool-using animal, and that the gift of fire, stolen by Prometheus from the gods, was the original source of man's development. Against that view, or rather as a supplement to it, I have sought to show grounds for believing that

Orpheus, not Prometheus, was man's first teacher and benefactor; that man became human, not because he made fire his servant, but because he found it possible, by means of his symbols, to express fellowship and love, to enrich his present life with vivid memories of the past and formative impulses toward the future, to expand and intensify those moments of life that had value and significance for him. Thus the strength of Achilles or the cunning of Odysseus, through their expression in the mind of Homer, had a long continuing effect upon other men: an effect that would otherwise, no matter how successful these heroes might have been in war and sport and seamanship, have vanished within the narrow limits of their lifetimes.

Man was perhaps an image maker and a language maker, a dreamer and an artist, even before he was a toolmaker. At all events, through most of history, it was the symbol, not the tool, that pointed to his superior function. Doubtless the two gifts necessarily developed side by side, since the arts themselves rest on fine motor coordinations and kinesthetic responses, and they need some kind of tools, outside or inside the body, for their expression. But even if this is true, Orpheus must be placed on as high a pedestal as Prometheus: the player of the lyre, he who almost rescued Eurydice from the technological underworld of Pluto, stands for a part of man's nature that Prometheus, for all his love of man, never could bring to its full development.

This position is of course a heretical one. So far have our American schools during the last generation become thing-minded, tool-minded, object-minded, so distrustful are they of symbols, that the fundamental instru-

ments of thought—language, number, and logic—have
almost disappeared from the curriculum, or are taught
with confusing concreteness in the common belief that
true education should be restricted to an experience
with "things" and with "real" situations. And similarly,
the same spirit has led to a pervasive neglect of religion,
ethics, the humanities, because these disciplines have,
in a world of machines, no obvious operational value.
Just the other day I received, from an educator in the
West, an anxious letter of inquiry which quoted a state-
ment recently made by a faculty member of a Junior
College. This very typical teacher asked: "In a time of
advanced technology when specialized training is neces-
sary for national survival and individual employment,
why are we expending energy on the nebulous whimsy
of general education?" How, my correspondent asks,
would *you* reply? I will not, at this point, give my answer
to this question, for in a sense this whole series of lectures
is an answer: but plainly if everything except technics is
a nebulous whimsy, what is left of man except a living
corpse, a corpse whose life is so meaningless and value-
less that it presents no sound reason for seeking either
individual employment or national survival? If that were
all that Prometheus did through his gift of fire, then
Jove was right, and he well deserved to be chained to
the rocks while the vultures plucked at his entrails.

But mind you, I am not trying to lower the status of
Prometheus. I am merely seeking to challenge the one-
sided dominance of the Promethean myth: the belief
that for the greater part of his existence man is con-
cerned with improving the physical condition of his life,
particularly the elemental needs, as we conceive them,

for food, clothing, shelter, security, physical care. Even
those who were the earliest to revolt against the brutali-
ties and inhumanities of early industrialism, with its over-
whelming obsession with machines and tools, like
Thomas Carlyle, described man as a tool-using animal
and treated the Gospel of Work as if it were man's
earliest and ultimate testament. Following on that trail,
the early anthropologists and ethnologists, penetrating
beyond the chronicles and legends of historic times,
found evidences of human culture in ancient caves and
middens, and characterized whole epochs of human ex-
istence by the kind of tool and weapon that they dis-
covered: eolithic, paleolithic, mesolithic, neolithic ages,
gave way in their scheme to a copper and bronze and an
iron age. They associated each human characteristic with
a technological advance.

Now this recognition of the human importance of
technics was indeed one of the radical discoveries of
modern times. Bacon in *The New Atlantis*—that first
utopia of the machine—at the very beginning of our
period proposed to honor inventors and scientists in the
way that mankind had once honored statesmen, saints,
philosophers, and religious prophets; and Karl Marx, an
excellent sociologist of invention, if a malign prophet,
pointed out that the means by which a culture gained its
living and mastered the physical and economic problems
of existence, altered profoundly its spiritual attitudes
and purposes. These efforts to give man's daily work a
new dignity and meaning were, in the first instance,
sound: indeed, stimulating and challenging. The world
had too long overlooked the significance of technical
effort. To the old categories of the good, the true, and the

beautiful, modern man added an important factor that slave cultures had overlooked or degraded: the useful. That was a notable human advance.

This very perception should have made us allow for the ideological wind, created by our own age, in interpreting man's nature: if we had recognized the overvaluation of technics that in fact characterized Victorian times, we should, in the interests of objectivity, have attempted to correct that bias. But no; even within the last generation, a philosopher as resolutely concerned with life in all its creativity as Henri Bergson, proposed that we should drop the Linnaean classification of man and call him not Homo Sapiens but Homo Faber, Man the Maker. This preoccupation with technics even caused Bergson to misinterpret the very nature of language, treating it as if it originated in the same tendencies as led man to create tools, seeing language in its relatively late tendency to conceptualize and geometrize experience, rather than in its original form, visible to us in the intercourse of a mother and her baby, as the vehicle, par excellence, of emotion and intuition, of fellow feeling and love, with a minimum of intellectual content.

When philosophers as exquisitely sensitive to the nature of living organisms as Bergson could fall so unthinkingly into this popular stereotype, there is little wonder that his colleagues in other departments were equally blind; so that, until recently we have taken for granted that, since we ourselves live in a Machine Age and boast of that fact, every other age was correspondingly dominated and influenced by its tools and technical devices. Despite our own devaluation of symbolism we had nevertheless made the Machine the symbol of life itself, and

transferred our own obsession with that particular idol to every other phase of human history.

Meanwhile, the facts needed for a more informed interpretation of technics were pouring in on every hand, with every fresh investigation of either surviving primitive peoples or prehistoric remains. In our museums the facts were long staring us in the face, without our having the will or the gift to interpret them. In the very hall of our museums of natural history, for example, where there is a great array of tools and weapons, some so early and primitive that they are hardly to be identified as such, one sometimes finds reproductions of the early cave paintings from Altamira and the Dordogne. The contrast between these two sets of artifacts should long ago have impressed us. One has only to compare the cave paintings of the Aurignacian hunters with the tools that they used to see that their technical instruments, even if eked out with wood and bone instruments that have disappeared, were extremely primitive, while their symbolic arts were so advanced that many of them stand on a par, in economy of line and esthetic vitality, with the work of the Chinese painters of the Sung dynasty.

The fact is that, as a technician, primitive man was relatively a duffer. Though his tool-using habits may have developed at quite as early a period as his symbol-making propensities, they were confined to a more recalcitrant medium; and they demanded a far greater amount of concentration and persistent effort than primitive man willingly makes. While there is a fairly steady progression in form from the earliest tools and weapons of stone down to those of historic times, the development, which takes place over a period reckoned in five-

thousand-year spans, is painfully slow. Early man had created vast and wonderful symbolic structures in language at a time when a handful of tools sufficed to meet his needs in hunting and agriculture; indeed a modern business organization or a modern factory is the only kind of technical apparatus that corresponds, in complexity and articulation, to such a highly complicated symbolic structure as a "primitive" language.

Throughout history, up to the sixteenth century A.D., the technical means developed slowly. So a civilization of great complexity arose in Egypt and Peru before the invention of the wheel as a means of transportation. If man were preeminently the tool-using animal, this long backwardness in technics would be hard to account for. Only after his symbolic functions had reached a high degree of maturity, did he begin to develop his technical capacities—and then, somewhat reluctantly, with a sense of being defrauded, if not degraded, by the necessity of giving so much of his life to the preparatory acts of gaining a living. So that proverbially, until our own time, men looked back to this earlier pretechnical period as a Golden Age, since it was a period without organized war, slavery, or compulsory labor, three of the chief criteria of that very ambivalent advance to what we call civilization.

Do not misunderstand my intention here. In correcting the biased account of man's nature and aptitudes, by those who overvalue technical processes and center attention too exclusively on the mastery of the physical conditions of living, I would not deny the essential part played by man's laborious technological advance. Man's extraordinary adaptability, his success in spreading to

every climate, of making use of every kind of environment, is partly the result of his growing technical facility. Man's manipulativeness and his inquisitiveness combined to make him an active inventor, no longer taking the world as he found it but patiently molding it closer to his real or imagined needs. Hence his constant sampling of possible materials for food, clothing, shelter, his imitative burrowing into the earth to bring up metals whose very existence he could hardly have known of in advance; his fascination with fire and water, with the effects of baking, drying, fermentation, his constant deepening of causal insight in his technological adaptation of means to ends, as in the invention of a score of ancient tools and simple machines from the harpoon and the blowgun to the needle and the safety pin.

All these achievements played an essential part in human development. Man's success in technics depended, however, upon two conditions. One of these was beneficial to the development of his personality, the other in some degree inimical to it. The great original contribution of technics was not merely to man's physical life, but to his sanity and general balance: it gave him a certain kind of respect for the nature of the materials and processes with which he worked, a sense of the painful fact that no amount of coaxing or cajoling, no repetition of spells or runes, no performance of sympathetic magic, could change a block of flint into an arrowhead or a knife, or make water boil unless the fire was hot enough. Man's dreams and wishes, his emotions and feelings are, as I shall continue to insist, an essential part of his life, but they are certainly only a part; and it was important for man's further development and maturity that he should

recognize that there are certain conditions of nature that can be mastered only if he approaches them with humility, indeed with self-effacement.

This respect for processes and functions did not come easily to man; indeed, his very invention of signs and symbols, though it widened the sphere of human cooperation, made him impatient of activities of a nonhuman kind whose nature he could not effect by purely symbolic means. Yet in dealing with the forces of nature, man's animism got him nowhere. He might attribute willful mischief to a pot that leaked or to a basket that came apart when it was filled, just as a friend of mine once saw a Russian peasant furiously kick a cart because its axle had broken; but he could not come to terms with these recalcitrant objects by any amount of sympathetic communication. Eventually, he would have to overcome his anger or indignation sufficiently to patch the leak or reweave the badly woven osier, if he wanted to make it perform its function. That humility before the object, that respect for function, were essential both to man's intellectual and his emotional development.

From the beginning, then, a willingness to accept the hard facts, an understanding of the impersonal nature of things, underlay man's success both in finally dominating nature and even in coming to terms with himself; since up to the point where the culture takes over and the personality develops, man, too, is a product of nature. That matter-of-factness stands in direct contrast to the creative daring, the imaginative leap beyond himself, that came with man's development of the symbol. Until modern times, when technics itself learned to make use of symbolism of the most refined order in planning and

controlling and ordering its operations, invention was a slow, piecemeal process, so difficult of achievement in any major department that, once it took place, any further innovations would be looked upon as dangerous. Man had to pay so dearly for his early technological acquisitions that he was in no mood to forfeit them by continued changes in either the manner of fabrication or the product. Even now there are departments of technics, such as textiles, where the essential processes of spinning fibers and weaving threads have not undergone any major change since neolithic times; while the best product that the machine can turn out today is qualitatively no better than the product of the Damascus weaver twenty-five hundred years ago.

There is one other characteristic of technics, as opposed to the symbolic arts, that must here be noticed, in addition to its matter-of-factness; and this is an association, possibly existing at the very outset, and certainly increasing with every great technical advance, with a mechanical uniformity and repetitive order. This capacity for order, this interest in order, seems to be the source of a particularly human value. The trait itself becomes visible in infancy: babies can amuse themselves by repeating the same sound indefinitely, and children like to hear the same story, told in exactly the same way, with not the slightest incident altered. That capacity may lie at the bottom of ritual and language; it certainly contributed to the development of technics. When man began to observe the movement of the sun and the planets, he became aware of order of the most magistral kind, cyclical, recurrent, undeviating, in nature itself: the thirteen lunar months of the calendar, the ten lunar

months for gestation. The existence of such order is another hard fact; and man's astronomical discoveries in neolithic times were probably a greater contribution to his security and well-being, through his increased mastery of agriculture, than any other single discovery since that of fire. Cosmic order, however, with its sense of fate, of inexorable necessity, of implacable movement, allows little play to human wishes and human desires; so, if the symbol endowed man with a sense of godlike power and creativeness, the simultaneous advance of science and technics, at a relatively early period in man's historical development, gave him a further insight into the need of conforming to nature and accepting the conditions he finds waiting him in the outer world, as a necessity of his survival.

Order of any kind gives man a sense of security: it is the changeful, the unexpected, the capricious, in other words the unpredictable and uncontrollable, that fill him with anxiety and dread. Hence whenever man becomes unsure of himself, or whenever his creative powers seem inadequate, whenever his symbolisms breed confusion and conflict, his tendency is either to find a refuge in blind Fate, or to concentrate upon those processes in which his own subjective interests are not directly involved. Our psychiatrists have discovered, in recent years, the genuine healing value of mechanical processes like weaving; and weaving remained, down almost to modern times, the highest type of mechanical order, for once the warp is set and the threads chosen, only the smallest play of freedom is left in the casting of the weft. This submission to orderly processes of work is not one of the least benefits that technics has bestowed on man-

kind. Along with the willingness to accept hard facts, to deal without foolish make-believe with materials and forces of the natural environment, goes a readiness to accept an impersonal order, not least in its regularities and repetitions, its rigorous standardization.

Though this schooling proceeded slowly, since it is at war with man's narcissism and self-love, with his free fantasy and his illusions, with his willfulness and his vanity, it has left a certain deposit of common sense in every age. If you would melt iron, you must blow extra air on the fire, or the ore will not melt; if you would fire a clay pot successfully, you must knead the clay thoroughly and not leave any air bubbles in it. In the slow course of history, that sort of recognition of the objective condition of success in the arts not merely caused the peoples who utilized such knowledge to prosper, but it progressively delivered man from the great trap that man's early mastery of symbolism had set for him—the belief that by means of these great magical instruments, images and words, he could directly command the course of nature.

Man's need for order and power turns him toward technics and the object, precisely as his need for playful activity, for autonomous creation, for significant expression, turns him to art and the symbol. But however important man's technical achievements are to his survival and development, we must not overlook the fact that they have, for the greater part of historic times, been achieved only at a painful sacrifice of his other functions. Except to meet pressing needs and interests, few men would devote themselves to a whole lifetime of mechanical work; indeed, those forms of work that are most

effectively dehumanized—like mining—were for long treated as punishment, fit only for condemned criminals. Not merely are the harsh duties of repetitive toil historically the work of slaves, or of a proletariat that would not willingly undertake such burdens except under threat of starvation or physical punishment, but in order to fare well at these tasks modern man must, to a certain degree, turn his back on more organic interests; to succeed in operating machines he must himself become a subsidiary machine.

And here we confront an interesting fact: the fact that man's greatest achievements in mechanization were first tried out on himself in the monastery, the bureaucracy, the army. The systematic drill and order introduced into warfare by military leaders in the sixteenth century was but the preliminary step toward transferring mechanical methods to extrahuman machines. So, too, even earlier, the strictly depersonalized life of the monastery, with its renunciation of sensual indulgences, with its strict regularities of office, with its orderly timing of every part of the day, gave rise to mechanical ingenuities for time-keeping, and to the regular distribution in time of all human activities. To condition ourselves to accepting regular hours for meals, regular hours for sleep, regular hours for recreation, even, as with Tristram Shandy's father, with his monthly winding of the clock, to regular intervals for sexual intercourse, all this was fundamental to our other mechanical performances. Finally, it was the depersonalization, indeed the demoralization of business activities, through their being channeled through the abstract medium of money, that laid the foundation for the equally abstract and depersonalized world of science,

where, as Galileo observed, only quantities counted, and qualities were, by the very terms of scientific method, disqualified.

These habits of mechanization, this submission to routine and drill, this willingness to deal in familiar terms with the nonorganic and with what, from an organic or human standpoint, looks deformed if not frightful, were not achieved without considerable resistance. Not until our own age did man prove willing to throw his whole subjective and qualitative life overboard. The development of technics, in its pure form, was curbed by man's inveterate tendency toward play and make-believe, toward fantasy and symbol, toward values that derive from other aspects of the personality. Professor John Nef has properly emphasized this happy retarding effect in his lately published discussion of modern industry and war. Even with the most sober kinds of tool and utensil, whose workaday requirements are not in the least enhanced by images, from the very earliest stages onward one sees the application of images and symbols, sometimes meaningful patterns connected with religious perceptions, sometimes purely esthetic elaborations, done for the sake of leaving a specifically human imprint on an object—a vase, a piece of cloth, a shield—that would otherwise seem too starkly cold for use, if the artist had not, so to say, set his special mark on it. Until our age, people felt, it would seem, that a work of technics was crude and unfinished unless the maker had embellished it with some reflection of his own life. So even the earliest of bronze age shields are embossed with circles that add nothing to their protective efficiency; while, in the Iliad, the fabulous shield of Achilles, as

described by Homer, was so replete with imagery that it constitutes a sort of microcosm of Greek life. So long as the handicraft worker remained in command of technical operations, working slowly and pleasurably on the job, the tendency toward economy and efficiency, toward functionalism, was counterbalanced by the desire to exhibit human value and purpose, by the tendency to enclose in an intimate human association the practical object.

But note: we may easily underrate the amount of dull and repetitive work even the freest craftsman is compelled to do, though he work under ideal conditions. Indeed, the overemphasis of the creative moments in art, the tendency to picture esthetic creation as one long, fervent, spontaneous activity, without severe toil and painful effort, without a constant mastery of technics, is one of the sure indications of the amateur and the outsider. Looking at a cathedral like Chartres or Rouen or Bamberg, for example, the modern eye is so impressed by the wealth of the sculpture that the whole fabric seems like the work of a guild of imaginative artists, who turn every chore into a play of happy fantasy. That is a very partial reading of such a structure. As the medieval historian G. C. Coulton has well reminded us, the greater part of the stones that make up a cathedral are foursquare blocks, one shaped as much like the other as possible, to facilitate their laying and bonding; in other words, the hewing of these stones to their geometrical shape involved repetition, standardization, and careful measurement, with a maximum amount of systematic labor and a minimum of spontaneity. He is right in so reminding us; and what he says applies to practically

every form of art. Each art has its technical side, and technics involves calculation, repetition, laborious effort, in short, what would often be, were it not for the ultimate end of the process, sheer monotony and drudgery. But in the period when handicraft dominated, the artist and the technician arrived, as it were, at a happy compromise, because, for one thing, their roles were assumed by the same person. By this *modus vivendi*, the artist submitted to the technical conditions of fabrication and operation, schooling himself to do a succession of unrewarding acts in return for two conditions: first, the comradeship of other workers on the job, with the chance for chaffer and song, companionship and mutual aid in performing the work; and second, the privilege of lingering with loving care over the final stages of the technical process and transforming the efficient utilitarian form into a meaningful symbolic form. That extra effort, that extra display of love and esthetic skill, tends to act as a preservative of any structure; for, until the symbols themselves become meaningless, men tend to value, and if possible to save from decay and destruction, works of art that bear the human imprint.

Except in the sense that works of art have a survival value through appeal to human sentiment, which things of pure utility may lack, no matter how carefully fashioned, there is no way in which this happy compromise can be defended, from a purely technical point of view. A water spout does not drain water more effectively off a roof because it comes out of the mouth of a carved gargoyle; and the roof itself, if soundly made, is not a more efficient form of shelter because it has been lifted, by means of interlaced vaults and piers, two hundred

feet above a congregation, instead of being carried by much more direct and simple means just high enough above their heads to give them the requisite number of cubic feet of air. All those specific interests which separate the architect from the builder, the sculptor from the stone mason, the fresco painter from the whitewasher, are, from the standpoint of the technical structure or product, entirely superfluous. More than that: they make demands on time, energy, vitality that it would seem hard sometimes to justify in ages when the common man was often scantily clad in winter and meagrely fed at most times of the year. But in the times when art has flourished, an intense inner life, a meaningful and valuable life, seemed more important to people than a merely long life spent in useful mechanical toil, without passion, without ecstasy, without a glimpse of heaven. This concern with art slowed down the processes of production. It utilized energy and human ingenuity that might have gone into the mass production of functional objects. But note: where both aims, the esthetic and the technical, were pursued together, it had the happy result of producing an harmonious relation between the subjective and the objective life, between spontaneity and necessity, between fantasy and fact. These moments of balance between art and technics, when man respects nature's conditions but modifies them for his own purpose, when his tools and machines regulate his life, freeing it from disorderly subjectivity, but do not dominate it, represent a high point in any civilization's development.

Now the dynamic equilibrium on which all life depends is a difficult one to maintain, and nowhere has this been more true than in the balance between art and tech-

nics. Esthetic symbolism for a long time seemed to man either a short-cut to knowledge and power or an adequate substitute. So he applied it, not merely to things that could properly be created or formed by these methods—works of poetry and art, systems of conceptual knowledge like mathematics, or patterns of law and custom—but also to the physical environment and to natural forces: he foolishly invoked art and ritual to bring on rain or to increase human fertility. Without the counterbalancing interests and methods of technics, man might easily have gone mad, in that his symbols might have progressively displaced realities and in the end have produced a blind confusion that might have robbed him of his capacity for physical survival. At some point in his existence man must leave his inner world and return to the outer, must wake up, so to say, and go back to work. The tool tended to produce objectivity or matter-of-factness, as my old teacher, Thorstein Veblen, used to call it, and objectivity is a condition for sanity.

Human history, unfortunately, discloses many symbolic aberrations and hallucinations. Perhaps the fatal course all civilizations have so far followed has been due, not to natural miscarriages, the disastrous effects of famines and floods and diseases, but to accumulated perversions of the symbolic functions. Obsession with money and neglect of productivity. Obsession with the symbols of centralized political power and sovereignty, and neglect of the processes of mutual aid in the small face-to-face community. Obsession with the symbols of religion to the neglect of the ideal ends or the daily practices of love and friendship through which these symbols would be given an effective life. In the case of the Greek cities

of the fourth century B.C. or the Italian cities of the fifteenth century, I would even say that an overpreoccupation with the fine arts themselves caused men to lose their sense of reality and to forfeit their liberty to the mainly symbolic seductions of costume and painting and public ceremonial and ritual. The disorganization and derangement of the symbolic functions, their proliferation at the expense of life, their overriding of man's daily need for honest labor and nourishing bread has too often in history meant a threat to man's very existence. Complete attachment to the symbol, complete withdrawal into an inner world, can be as fatal to man's development as complete externalism.

We are now, I believe, in a position to understand why, during the last few centuries, Western man's absorption in the machine not merely increased the amount of physical power available, but actually gave him a great sense of subjective release. Even when he conceived of the universe as a machine, or his own organism as a machine, the kind of order promised by that conception delivered him from the state of curdled subjectivity that he found himself in. Unable to bring the various parts of his life into harmony, he traded wholeness, so to say, for order; that is, order of a limited mechanical kind. That order itself has a certain subjective value and therefore can, despite its limitations, serve as the material for art. Though one part of the modern movement in art, the expressionist and surrealist wing, has taken refuge in unconditioned fantasies almost unconnected with any outer perceptions or activities, another part, that begun by the cubists and constructivists, has sought to find equivalent symbols for the activities of science and the

forms of the machine. Sometimes, as in the early work of Léger, this takes the form of transposing organic forms into mechanical forms, making human beings mere cylindrical objects as if turned in a lathe. Sometimes, it carries further the abstract arrangement of volumes and planes, to accentuate the uniqueness, for human perception, of the mechanical forms the engineer has been creating. Sometimes, as in the paintings of Piet Mondrian or the sculpture of Ben Nicholson, it takes the form of creating a geometrical order, so elemental that it not merely eliminates the human personality, but in another moment would also eliminate the symbol itself. All these attempts to assimilate the machine and make the human spirit at home with the machine are in fact efforts to reassert the values of the person, within the very realm from which, in both theory and practice, all but a fragment of the personality, the pure intellect, has been excluded. This effort to make mechanical order and objectivity itself a subject of art has served in some sense as a counterpoise to the tendency to relapse into the primitive and the infantile, the disordered and the perverse— the reaction of those who feel excluded from the modern world and who, to maintain their very status as human beings, must in some sense seek revenge. But though cubism and constructivism, and all the movements in the other arts that derive from these original intuitions, have made a step toward integration, they are obviously incapable of effecting a complete synthesis, since, on their own terms, they must suppress emotion, feeling, sentiment, any tendency toward organic richness of form.

Yet this attempt to assimilate the meaning of technics, to take in, as part of one's conscious perceptions and feel-

ings, the new area of human experience opened up by the machines, was, as far as it went, a healthy act. In the minds of the Futurists, headed by the Italian Marinetti, its dynamism, its emphasis upon speed, and even with him a certain pre-fascist delight in violence for its own sake, were a little ridiculous, if not repulsive. For all that, no one can hope to achieve any kind of personal integrity in the modern world who is not at home with the machine, who attaches his values only to a premachine culture, and who does not realize that, in the very development of the machine a certain part of the human personality, the rational intellect, came to a development it had never reached before. Within its own mechanical sphere, the spirit relies on calculation and leaves nothing to luck or chance: the sloppy, easygoing habits that were once possible in many operations could only result in a prompt loss of life, for example, if a garage mechanic bolted on wheels of a car without checking up on his performance. This respect for the object, this conscious interest in the actual go of things, this "functionalism," to use a slang word lately popular in esthetics, is in fact a valuable contribution to the whole personality. Not merely does it exclude irrelevant emotion; but with its sense that the person himself is also an object, to be viewed from the outside by others, it tends toward a certain underemphasis, a certain decent self-effacement, which is in the best style of our epoch.

Sometimes this quieting down of the more obstreperous aspects of the inner life is called objectivity; and you will notice that I spoke of this at the beginning with more than a faint touch of sarcasm. So let me explain what I mean. Neither the suppression of emotion or de-

sire nor respect for the object should, from my point of
view, be equated with true objectivity. And why? For
the simple reason that true objectivity must include
every aspect of an experience, and therefore one of the
most important sides, the subject, himself, must not be
left out. When we are truly objective we not merely see
things as they are, but reciprocally things see us, so to
say, as *we* are: how we think, how we feel, what our pur-
poses and values are, all enter into the final equation.
And accordingly, while technics must be absorbed into
the whole personality and while some of its order, some
of its regularity, some of its neutrality are important con-
tributions to an integrated person, they are but parts of
a more significant whole. Emerson said that life was not
worth having just for doing tricks in; and technics is not
just a way of running to and fro and seeking out many in-
ventions: it is a means of creating a human personality
more capable of meeting the forces of nature on even
terms and more capable of directing rationally its own
life. When human behavior becomes abjectly mechani-
cal, technics does not serve this purpose; but when the
lesser objectivity of the machine process is absorbed into
the greater objectivity of the developing person—not
depersonalized but truly impersonal, not devaluated,
but actually richer in values because of his grasp of the
machine—then the mechanical development that at
times seems so empty of human content will prove to be
a boon to the human spirit itself. In that sense, the per-
sonal discipline of technics is more important than any
addition it promises to our power and wealth.

Unfortunately for our fuller absorption of the mean-
ings and values of technics, the machine has now de-

veloped neurotic phenomena of its own; or, rather, our overattachment to the machine has brought about a neurotic condition in ourselves. The drill and regularity that technics has introduced into every department of existence has given to our daily routine, whether in the office or the factory or the farm or the school, the appearance, and in no little degree the actuality, of a compulsion neurosis: that form of neurosis in which the victim is condemned by his mental state into repeating, over and over again, one restricted set of motions, like wringing his hands, motions which, in their repetition, their monotony, their mechanical limitation, are singularly like those of a worker on an assembly line—and vice versa. In the higher realms of technics, even more sinister neurotic phenomena are visible; for the expanding will-to-power, untempered by emotions or sentiments of any kind, insulated from moral standards, cut off from any saving sense of humanity, tends to produce a paranoid state, a state of moral alienation and unfeelingness that is singularly apparent in those who have planned the mass exterminations that have now become an accepted instrument of what we call, in a glib, repulsive euphemism, "total war." It is these neurotic compulsions and homicidal impulses, this creeping irrationality that is now spreading like some fatal blight from one institution to another in our civilization, that invades our fantasies with sadistic images and turns our worst nightmares into the living realities of Buchenwald and Belsen, of Hiroshima and Nagasaki—it is these very tendencies that now prevent technics from playing the useful part it long played in disciplining human fantasy and overcoming the tendency of symbolism to magical perversion.

So we are now faced with a situation quite different from that which characterized Western Europe in the fourteenth century, when the disintegration of medieval civilization became visible. Europe, at that time, had created an imposing symbolic structure, in the dogmas, the philosophy, the ritual, and the daily pattern of conduct promoted by the Christian Church. Medieval civilization was overcome not by its weaknesses but by its achievements. So successful was this effort at symbolization, this habit of seeing every fact and every event as a witness to the truths of the Christian religion, that a plethora of symbolic "inner" meanings lay over every natural event and every simple act: nothing was itself or existed in its own right, it was always a point of reference for something else whose ultimate habitat was another world. The simplest operations of the mind were cluttered by symbolic verbiage of an entirely nonoperational kind. In order to come clean, man took refuge in a different kind of order and a different kind of abstraction: in mechanical order, in number, in regularity, in drill. Unfortunately, Western Man in his search for the object, presently forgot the object of his search. In getting rid of an embarrassing otherworldliness he also got rid of himself. In the effort to achieve power and order by means of the machine, modern man allowed a large segment of his personal life to be displaced and buried. In the very act of giving authority to the automaton, he released the id and recognized the forces of life only in their most raw and brutal manifestations.

So, today we confront just the opposite problem to that faced at the end of the Middle Ages. Technics itself, by its overdevelopment at the expense of the hu-

manities and the arts, has given rise to a special kind of aberration—the result of undue success in displacing emotions and sensitivities and feelings, in disregarding man's deepest sources of life and love, in cutting itself off from the values and purposes disclosed by religion and art. If we are to save ourselves from the threatening miscarriage of the technical functions, we must restore primacy to the human person; that is to say, we must nourish those parts of man's nature that have been either neglected or made over into the image of the machine. To overcome the distortions of technics, we must cultivate the inner and the subjective as our ancestors during the last three centuries cultivated the outer and the objective. But our proper goal is a balance between these essential aspects of the personality. In my succeeding lectures I shall try, by concrete illustrations, to show what is meant by such a reconciliation and balance.

From Handicraft to Machine Art

IN ORDER to understand more fully the problems that modern man confronts, in his own person, through the divergent development of art and technics during the last few centuries, I have, so far, adopted the old pedagogic trick of examining them at their point of origin—in their purest form. So I have treated art as mainly an expression of the inner life without any reference to the physical media and processes and concrete operations through which even the most etherealized form of art must be expressed. Similarly, I have treated technics, so far as possible, in an equally pure state, emphasizing the impersonal conditions that enter, even in primitive cultures, into man's control of the forces of nature.

But in actual history, this separation does not hold. Art and technics go together, sometimes influencing each other, sometimes merely having a simultaneous effect upon the worker or the user. So, even on some of the earliest stone age tools or weapons, when the material

lent itself to the purposes of symbolic expression, we observe carvings, scratchings, or etchings of a character that does nothing to further the work in hand. Here the worker had something to say as well as something to do. Even while he was serving Prometheus he was listening, with an ear half-cocked, to the distant sound of Orpheus's lyre, or the wildest notes of Pan's pipes. Doubtless rhythm and form did in fact lighten the psychological load of hard physical labor, as Karl Buecher long ago suggested in his classic treatise on Work and Rhythm; and art, at that stage, may have both taken the curse off monotonous work and even increased the efficiency of the worker.

Over a large part of human history, then, the tool and the object, the symbol and the subject, were not in fact separated. All work was performed directly by human hand, and that hand was not a detached hand, a specialized hand, it was part and parcel of a human being who, no matter how faithfully he followed his craft, had many other interests than the performance of work. Not every part of craftsmanship, as I reminded you in the last lecture, is by nature creative and esthetically rewarding. But even the meanest slave, with a tool in his hand, would feel the impulse to give the object on which he was working something more than was required to make it work; he would linger over it, at the least, to heighten its finish, or he would modify the form in some degree to make it delight the eye as well as perform its function. In some cases, as in the fashioning of that beautiful tool the American ax, it is hard to say, when we consider the perfect shape of the handle, whether the practical or the

esthetic purpose was dominant, so completely are both requirements met.

In the earlier stages of culture, I must remind you again, the symbolic interest usually dominated the technical one. In pottery, for example, the breasts or the trunk of a woman might suggest the rondures of the jug or the vase; so, too, as Vitruvius tells us in his treatise on architecture, the column might be turned into the figure of a woman to form a caryatid, in order to symbolize the humiliation that had befallen the inhabitants of a certain conquered city—their women were condemned to serve as supports of the entablature. Sometimes, instead of resorting to these more obvious symbolisms, the craftsman, adhering strictly to functional needs in the development of his form, would finish it off by more playful modes of decoration. Having given good form to his oil jug or his bowl he would add to it some "leaf-fringed shape" of men and maidens, in Tempe or in Arcady, to remind the user, as one man speaking to another, that life was more than a matter of shaping utensils or storing food in them.

These forms of extraneous decoration belong to the system of handicraft and are usually absent from machines. From the very beginning real machines are startlingly matter of fact, objective, *sachlich* as the Germans say, whether we examine a bow-drill or a draw-loom. But even here the objectivity is not absolute; for by intimate use machines take on a certain personal, I-and-thou quality in relation to their operator, so that for long ships boasted a carved figurehead, and that somewhat capricious machine, the shotgun, likewise bore all sorts

of complicated ornament, though the more deadly and businesslike rifle quickly eliminated such fancies. What perhaps has caused decoration to disappear from sewing machines and typewriters during the last seventy-five years, as well as from so many other objects, like china and glass, is the fact that the so-called decorative art produced by the machine is as depersonalized as the functional object it decorates: in short, it is no more capable of stirring feeling than the machine itself, or rather less so, since it lacks the machine's own kind of integrity.

Now, however laborious many of the earlier processes of craftsmanship actually were, two things throughout the greater part of history served to redeem the whole process of technical development. One of them was that the operations were under the direct control of the craftsman himself. He took his own time about his work, he obeyed the rhythms of his own body, resting when he was tired, reflecting and planning as he went along, lingering over the parts that interested him most, so that, though his work proceeded slowly, the time that he spent on it was truly life time. The craftsman, like the artist, lived *in* his work, *for* his work, *by* his work; the rewards of labor were intrinsic to the activity itself, and the effect of art was merely to heighten and intensify these natural organic processes—not to serve as mere compensation or escape. Commercialized production for overseas trade may, even in ancient times, have introduced extraneous pressures into the work of the craftsman, making him hasten his pace, or lower his standards of sound workmanship, or scant his personal contribution, so that the work would no longer bear his inimitable

signature. But the fact that the handicraft worker is master of the process, so long as he respects the nature of his materials, was a great satisfaction and a support of personal dignity. The other reward of craftsmanship in many branches of art and technics was that the worker could pass, with further technical skill, from the operational to the expressive parts of his job. Through acquiring skill in technics, he became licensed, as it were, to practice art. At that stage, the machine itself makes a contribution to creative release. The potter's wheel, for example, increased the freedom of the potter, hampered as he had been by the primitive coil method of shaping pottery without the aid of a machine; and even the lathe permitted a certain leeway to the craftsman in his fashioning of beads and bulges. Up to a point, then, in all the industrial arts, technical development and symbolic expression go hand in hand. Who can say, indeed, whether the great string music of the eighteenth century would ever have been written had not violin-makers like Stradivarius placed in the hands of the composer such superb instruments as the violins they created?

As long as handicraft processes remained uppermost, say roughly until the middle of the nineteenth century in the more advanced Western countries, handicraft itself was the mediating factor between pure art and pure technics, between things of meaning that had no other use and things of use that had no other meaning. All the useful arts served in some degree as instruments of communication as well as agents of effective work. In pots and woven cloths, in houses and shrines and tombstones, in churches and palaces, the worker contrived not merely to do the job that must be done, but to identify himself,

to individualize himself, to express himself, to leave behind a message, sealed as it were in the bottle of art, for the pleasure and enlightenment of other men. There is one department of technics, however, where this happy relationship does not hold: the part governed from the beginning by a dehumanized pattern of life—mining and warfare. The overthrow of an integrated method of thinking and working and creating, governed by human interests and human norms, came into the Western World with the disproportionate development of mining and warfare. I have not time, in these lectures, to follow through that development and to point out what an unfortunate influence this had upon both the development of the machine and the whole course of modern civilization. It must suffice for me to remind you here of something I went into at some length in *Technics and Civilization,* that the destructive tendencies in modern technics—to deface and befoul the environment and to stamp out human life with ever increasing ruthlessness—stem from these two occupations. But here I want to concentrate on the more formative and beneficent aspects of technics; particularly with those parts that have encouraged man's higher life.

Now there is one other fact in connection with mechanization that has been insufficiently appreciated, I think, by most writers on the subject. I have already alluded to it in an earlier lecture and I shall go back to it now, since we are about to witness its effect upon the development of the art of printing. This is the fact that men become mechanized, they themselves are transformed into mechanical, uniform, replaceable parts, or they teach themselves how to perform, with accuracy, standardized

and repeatable acts, before they take the final step of inventing machines that take on these duties. The social division of labor precedes the mechanical division of labor, and the mechanical division of labor, in general, precedes the invention of complicated automatic machines. The first step is to reduce a whole human being into a magnified eye, a magnified hand, a magnified finger, subordinating every other function to that whose province is enlarged. This specialization takes place even under the handicraft system at a late stage in its development. By breaking the once unified process of work into a series of fractional operations, as in the famous pinmaking illustration of Adam Smith, the output can be increased at the simple cost of taking all the fun and interest and personal responsibility out of the operation for the worker. This may happen even without minute specialization and subdivision. So we have automatic bookkeepers, in the person of human beings, before we have mechanical calculating machines; we have photographic painting, too, at least three centuries before we have photography. This fairly general truth applies in full degree to the field I purpose to examine in the present lecture: the invention of printing from movable types.

I have chosen printing because this mechanical art is second only to the clock in its critical effect upon our civilization; and because in its own right it exemplifies the much broader passage, constantly going on in our own day, from the tool to the handworked machine, and from the machine to the completely automatic self-regulating device from which, at the end, almost every intervention of the human person is eliminated, except at the very beginning, in the arrangement of the works,

and at the very end, in the consumption of the product. Finally, and not least, I have chosen printing because it shows, in the course of its own development, how art and technics may be brought together, and how necessary it is, even for technical development, to have the person that presides over the process refresh himself constantly at those sources in life from which the symbol, in its purest forms, comes forth.

Probably many people in this audience know, at least in outline, the story of printing, so admirably put together by Thomas Carter, the veritable unraveling of a mystery from which only the very last link in the chain seems still to be absent. For one thing, though it is in the nature of mechanical inventions to spread widely from their original center, the spread of printing and the accessory arts upon which it depends, like that of papermaking, is one that wove into a single web the cultures of the East and West, with each part contributing its share to the final product. In a special sense, therefore, printing is a universal art, prophetic of that One World which our technical instruments make it possible for man now to achieve—though we do not yet know whether it will be one world blasted and ruined by atomic bombs or one world pushed to a higher plane of development through the abundant practice of mutual aid. At all events, printing swept across the world, from China and Korea, where movable types were first invented, into Europe, in the course of a century. We can trace its progress in a series of steps, by way of Persia and Turkey and Russia, till we find the first printed book in Holland and the first European book printed from movable types in Germany. This art had many begin-

nings in earlier civilizations, from signet rings to coins. It *might* have been applied to the printing of books at almost any moment for the last 2500 years. But before the method was applied to books a new social medium was necessary: a community that had abandoned slavery and was ready, indeed eager, to equalize cultural advantages once reserved for a ruling caste; so that the rise of free cities, of urban democracy, of an increasingly literate group of citizens gave an incentive to a method for manifolding and cheapening the process of producing books.

And here again—you must forgive me if I drive this point home a little insistently, to compensate for the more dominant opposite view—here again the esthetic symbol preceded the practical use. For the first application of printing was in the domain of art, the printing of woodcuts: it was only at a later stage that the interest in the word led to that consummate invention, so advanced, so modern at every point—the invention of movable type. For note what was involved in the concept of setting up a line of type by using separate letters cast on a uniform pattern in a mold: the movable type is the original model of the standardized, replaceable part, which some forgetful historians are inclined to attribute to a much later inventor, Eli Whitney, in his perfection of the standardized gun. Finally, the printing press itself, first hand-operated, then, in the nineteenth century power-driven, became one of the earliest pieces of standardized, increasingly automatic, machinery. Within a century of the invention of printing, the calligrapher, the hand-copyist, had been driven out the field of book production over which he had long presided; and yet,

so far from this being a serious loss, it was in its initial stages a mighty gain, since all that was good in the handwork was preserved, while some part of what was bad, the inevitable monotony and tedium, was eliminated. Within a generation of Gutenberg's invention, the book in fact reached a perfection in type, impression, and general form that has not in fact been surpassed by any later efforts.

To understand what was involved in this change-over from writing to printing, we must compare the difference visible at an earlier stage between cursive handwriting, longhand, and the more highly formed hand-printed letter. Though there is a typical element in all handwriting—so that one can identify the clerical hand or the humanist hand, the civil service hand or the Palmer method hand or the boarding school hand—there is no form of art that tells one so much, at every stroke, about the individuality of the writer, about his tone and his temper and his general habits of life. So truly is handwriting a key to the human personality that when one wants to refer to the highest type of individuation in art, we refer to the artist's signature. As you know, Chinese calligraphy usually accompanies a picture, done in the same style—visually a part of it. But this very individuality of handwriting is itself a handicap to the widest kind of communication. Reading would be a most laborious art if, on every page, one had to struggle with a new personality and master his vagaries of written expression as well as his thought. For the sake of general legibility and universality it was important that the human being who copied a book should achieve a certain kind of neutrality and impersonality, that he should sacri-

fice expressiveness to order, subduing his idiosyncrasies, making each letter conform to a common type, rigorously standardizing the product. The typical and the repeatable—what is that but the province of the machine? After a copyist repeated the same letter a thousand times, his letters would achieve that impersonal quality. And by habit and repetition, by restraint and humility, he brought the manuscript to a point of mechanical perfection at which the letters themselves could readily be transferred into movable types.

But note how perverse art itself can be when divorced from other equally central human purposes. From the standpoint of effective communication, the hand-wrought manuscript tended by its very elaboration to lose sight of its essential reason for existence. In this respect, its development was very similar to that we often find in other arts, a tendency on the part of human fantasy, once it is emancipated from the restraint of practical needs, to run riot, to seek to prolong the esthetic moment beyond any reasonable duration. In medieval cathedrals this sometimes went so far that Ruskin even discovered carving in places where no human eye but his own—if we except the original worker—had probably ever beheld it. Quite evidently this desire to prolong a pleasurable occupation, while it makes for a good life, has its own kind of shortcoming; and in the case of the book, the very esthetic excellence of the illuminators and illustrators served also to retard the process of copying and so limit the circulation of books. Even if the hand labor had been rough and quick, it would have produced too few; but since it was actually measured and meticulous, it served as a further brake on the spread of learn-

ing. How unique and precious books were, how well respected they were as works of art, we know from the state they come down to us in: no scrawls in the margins! no dirty fingerprints! no dog ears! But as long as art held production in check, there were never enough books, even in an illiterate age, to go round. So eventually, in the development of the manuscript, there came a point where the two impulses, the technical and the esthetic, came to a parting of the ways. The esthetic and personal part of copying was getting in the way of the practical offices of the book; and for the sake of increasing the circulation of ideas, it was time for the two sides of the art to separate. At that point, the machine entered, to take over the repetitive part of the process. As a result, printing itself reached maturity almost overnight.

Unfortunately, it took a long time to discover that, to be an art in its own right, the machine need not, in fact *must not*, attempt to imitate the special graces of handicraft art. If viewed from the ideal standpoint of the illuminator, aiming at purely esthetic effects, printing was indeed a poor makeshift; and the early printers themselves must have felt the force of this traditional judgment, for very often, right down to the nineteenth century, they gave the printed page many of the illuminator's embellishments: a certain floridness, a certain ornateness of figure and arabesque on the title page and the initial letters, surrounded the serene austerity of the text itself. But printing, even before the steam press and the linotype machine completely mechanized it, was essentially a new art, with its own special canons of taste, its own standards of esthetic expression. The early printers hesitated to let the type speak for itself. They thought

machine ornaments were better than no ornaments, whereas they should have realized that a certain chastity of statement, a certain reserve and underemphasis, is characteristic of good machine art; it is the function itself that addresses us, and the esthetic appeal must always be within the compass of a rational judgment. If the essence of machine art is the expression of function—if beauty here, in Horatio Greenough's memorable words, is the "promise of function"—then the main effort of the printer must be to convey the meaning of the writer to the reader, with the least intrusion of his own personality.

Behind the appearance of printing from movable types, apparently so sudden, and on superficial analysis just a great mechanical feat, we find a thousand years of self-discipline and esthetic training, which went along with the effort to respect the gifts of the spirit and to deepen the inner life. Some of that training still is important for those who would design typography. You might think that, once printing was achieved, it would be possible to cut loose entirely from these earlier sources; but in fact the continued interdependence of art and technics could not be better illustrated than in this wholly mechanical art. The great fonts of type, the platonic forms from which all later types down to our own day have been derived, were almost all cast within a century of the invention of printing. Sometimes the early books printed in these fonts seem a little too compact and crowded for our modern taste in reading, as if the designer still felt that the paper was as precious as parchment, and if he was to have wide margins, the lines themselves must be crowded together. But in general, nothing

more perfect, as print, has been achieved than the work of the early type designers and printers like the great Nicholas Jenson: people who were still under the spell of the old manuscripts. As soon as the art of the calligrapher fell into decay, the art of type design became more difficult, for in aiming at mechanical accuracy and finish, the designer often lost the precious touch of the hand itself. Once utilitarian and rational interests predominated over esthetic ones, as they did in the nineteenth century, there followed a series of lapses both in type itself and in the layout of the printed page: the Bounderbys and the Gradgrinds of Victorian capitalism, confusing ugliness with efficiency, seem to have preferred ill-proportioned, illegible, or downright ugly types.

When the revival of printing as an art began in the final quarter of the nineteenth century, largely under the influence of William Morris, those who started it refreshed themselves at two sources: the manuscript and the earliest printed books. Moreover, they wisely practiced the old hand art of calligraphy in order to restore their sense of form. Two of the best typographers I know today are remarkable calligraphers; and to receive a letter written in their beautiful hands is to remind one of all that has been lost by our overreliance upon the machine, and by the general haste and pressure that makes ordinary handwriting so ill-formed and uncouth. Here is a matter that has a much wider application than use usually realizes; namely, that one must never let the development of the machine get so far away from its sources in art and handicraft that we could not reinvent the art all over again if its higher secrets were lost. To speak in biological terms, man's relation to the machine

must be symbiotic, not parasitic: and that means he must be ready to dissolve that partnership, even forgo temporarily its practical advantages, as soon as they threaten his autonomy or his further development.

But there is something else involved in the fact that such a typical machine art as printing reached its highest plateau of achievement within a century of its invention; and this is the truth that, by very reason of its impersonality and standardization, a machine art, once it has achieved a high level of form, is not subject to endless variations: the main problem is to keep it at its original high level. Though the subjective arts often fall into stereotypes and fashionable molds, the fact is that man's inner life, when awakened, is inexhaustible; and repetition without variation and re-creation is fatal to the existence of the humane arts. This is not so with the arts of the machine. Here the type is the supreme achievement; for the sake of functional economy, for the sake of order and common use, the fewer new demands that are made, the better. The capital danger in the arts of the machine is misplaced creativity, in other words trying to make the machine take over the functions of the person. The path of advance in printing, for example, was in the opposite direction: pruning away the excrescences in type, left over from the old illuminators, with their fancy initial letters and head pieces and tail pieces, so that the true subject matter of printing, the words themselves, would be more visible to the reader, and so that, by their very form and spacing and proportion, they would in the most subtle way possible underline the meaning of the text. A beautiful book is no substitute for a readable book; and a readable book should

bring one closer to the mind of the author, not make one a prey to the whimsies of the typographer.

All this should explain why there have been no radical changes in type faces from the very beginning, at least within the roman fonts; and it should also explain why no radical changes are immediately in prospect. Some keener analysis of the physiology of the human eye or the psychology of reading might produce certain fresh variations: indeed, the greater space we now allow between lines and between words is an indication of such an adaptation. So, too, if we undertook to create a world language and began the wide use of an international phonetic alphabet, with all its strange new characters beyond our usual abc's, the typographer would have a considerable leeway for experiment in inventing new shapes. But these changes would be due to the growth of scientific knowledge, or, like the more mechanical cutting of modern type faces, they would be due to the objective conditions imposed by linotype setting. But in type, as in the other machine arts, we give up a certain subjective freedom in order better to serve a common collective goal: in the case of printing, universality, legibility, facility of understanding, and with all these qualities the widest possible distribution.

While painting has been going through the radical succession of changes that has brought into existence cubism, futurism, expressionism, and surrealism, the wildest notion that the painter's colleagues in typography turned up with during the craziest period of the twenties was that capital letters should be abolished, presumably in the interests of democracy, or that a font without shading or serifs—called with absolute inappropriateness

Modern Gothic—should be preferred to the older fonts. Unfortunately the absence of serifs and shading, though it may make the letters look a little more mechanical, does not in the least make them more legible, and as for doing away with capitals and punctuation, that is so far from being modern that it only takes us back to the earliest roman forms from which modern printing started.

In short, the machine, and the machine arts, when taken on their own essential terms, are necessarily stable, like all type forms, and there is nothing more fatal to a good machine form than irrelevant subjectivity, misplaced creativeness, meretricious uniqueness, as if produced by hand. As soon as you find such suspicious features in any machine form—as in the constant restyling of the less essential parts of a motor car—you know that the canons of conspicuous waste, dear to the businessman, and the newly rich, have gotten the better of the canons of economy and function; and that somebody is picking your pocket of money you might use for better purposes, under the pretext that he is furnishing you with art. The current name for that particular perversion is industrial design.

The two great results of the invention of mechanical printing have been characteristic, in some degree, of similar advances in all the industrial arts: they have been to standardize in a more rigorous fashion a product that was already standardized, and to progressively eliminate the craftsman himself in the act of freeing him from the drudgery of hand labor patterned on a mechanical model. If there was a certain loss in that change-over, it nevertheless was, I submit, a reasonable price to pay

for the benefit that printing conferred on the word—and the world; for, if it suppressed the copyist, it released the writer and conferred on him the privilege of talking directly to a greater number of fellow men than he had ever addressed before. Printing broke the class monopoly of the written word, and it provided the common man with a means of gaining access to the culture of the world, at least, all of that culture as had been translated into words or other printable symbols; doing so, it increased every man's range in time and space, bringing together times past and times to come, near and distant, peoples long dead and peoples still unborn. Recent generations have perhaps overestimated the benefits of literacy, for these benefits do not come about automatically, and they may be accompanied, if unwisely used, by a loss of firsthand experiences and contacts, a loss of both sense and sensibility, with an increase of pride and prejudice. But it is hardly possible to overestimate the handicaps of illiteracy; for that chains one to the world of the here and now, a form of cultural solitary confinement, fatal to human development. Again, though print undoubtedly accentuated man's natural eye-mindedness, to the point of actually impairing his vision by overstraining the eye, it also freed the mind from the retarding effects of irrelevant concreteness. Only now that we are falling back into a state of vacuous illiteracy, through the overdevelopment of radio and television, can we realize on what a low level of abstraction we should live without the benefit of the printed word. The swiftness and economy of print, compared with the interminable prolixity of the spoken word, more than made up for the

·other human qualities that were forfeited through the invention of the printing press.

What further innovations remain to be made in printing, other than the possibilities I have mentioned, are mainly on the technical side. They are similar to what has been happening in other departments of technics. One improvement that is surely coming, now that practically all manuscripts are in their final stages typewritten, is a completion of the automatic process with the aid of a scanner which will automatically set up type without the intervention of the typographer. When that final invention takes place in printing, this art will have achieved its theoretical limit of perfection, the limit long ago envisaged by Aristotle, when he observed, in words I am fond of quoting, that slavery would disappear when musical instruments would play by themselves and looms would weave by themselves: for then, he added, "chief workmen would not need helpers, nor masters slaves." The other possibility, also a technical one, would lead in the other direction, not toward automatism and large-scale mass production, but in the direction of making printing or its equivalent possible by a more simple and direct method, lending itself to small-scale production and therefore to a larger measure of personal expression. Many such processes, from mimeographic to photographic offset printing, are already available. William Blake was perhaps only a little ahead of his time in his personal method of reproducing his poems in small quantities. Thanks to my friendly Japanese translator, Professor Tsutomu Ikuta, I have in my possession a charming version of Edmund Blunden's poems, done in

Japan, hand-lettered and then photographed and repro-
duced by the offset process, a sort of modern version
of the earliest method of wood-block printing; and the
directness and simplicity and beauty of the product, its
exquisite fitness to the work in hand, with its modest de-
mands for material support, perhaps indicates a way in
which we can overcome the banal effects of mass produc-
tion, with its abject dependence upon a large market.
This means of printing will perhaps be one of the answers
to the modern publisher's barbarous reluctance to con-
sider the publication of poetry, for example, as anything
but a painful personal favor on his part.

From my point of view, the greatest developments to
be expected of technics in future, if once the philosophy
I have been advocating becomes generally accepted, will
not be, as we are usually led to think, in the direction of
universalizing even more strenuously the wasteful Amer-
ican system of mass production: no, on the contrary, it
will consist in using machines on a human scale, directly
under human control, to fulfill with more exquisite
adaptation, with a higher refinement of skill, the human
needs that are to be served. In this matter, I am wholly
on the side of Peter Kropotkin; for the author of *Mutual
Aid* and *Fields, Factories and Workshops* understood
that advance of the machine, as an agent of a truly hu-
man life, meant the use of small-scale units, made possi-
ble by the further progress of technics itself. Much that
is now in the realm of automatism and mass production
will come back under directly personal control, not by
abandoning the machine, but by using it to better pur-
pose, not by quantifying but by qualifying its further
use.

You perhaps understand now something that may, at an earlier moment, have puzzled you a little: why I chose to take modern printing, by the invention of movable type, as the key art in discussing not merely the passage of handicraft art into machine art, but in further elucidating the essential nature of technics itself. I chose type because the whole development of technics, so long as it is conforming to its proper canons, is in the direction of the typical—and what could be more typical than type? Like the scientific knowledge that contributes so much to this development, it is the repeatable, the standardizable, the uniform—which is to say, again, the typical—that is the essential field of technics. This concern for the type, if carried into all the operations of industry, should have the effect of enabling us, in one department after another, to establish a common background of order, a highly simplified order based on the utmost degree of functional efficiency and economy, an order that demands a minimum contribution from the rest of the human personality. But once established and perfected, type objects should have a long period of use. No essential improvement in the safety pin has been made since the bronze age. In weaving there has been no essential modification in the loom for over a century. And what is true for machines holds good in no small degree for their products. When the typical form has been achieved, the sooner the machine retreats into the background and becomes a discreetly silent fixture the better. This again flies in the face of most contemporary beliefs. At present, half our gains in technical efficiency are nullified by the annual custom of restyling. Extraordinary ingenuity is exercised by publicity directors and industrial designers

in making models that have undergone no essential change look as if they had. In order to hasten style obsolescence, they introduce fake variety in departments where it is irrelevant—not in the interest of order, efficiency, technical perfection, but in the interest of profit and prestige, two very secondary and usually sordid human motives. Instead of lengthening the life of the product and lowering the cost to the user, they raise the cost to the user by shortening the life of the product and causing him to be conscious of mere stylistic tricks that are without any kind of human significance or value. This perversion of technics in our time naturally saps the vitality of real art; first by destroying any sound basis for discrimination and then by taking energy and attention away from those aspects of human experience in which the unique and the personal are supremely important.

And now I come to a final point, which is essential to our understanding of the relations of art and technics in the world today. There is no extraneous way of humanizing the machine, or of turning it to the advantage of that part of the human personality which has heretofore expressed itself in what we may call the humane arts. You do not make a machine more human by painting it with flowers, as our ancestors used to paint typewriters and coffee grinders, or by spoiling its smooth surface with mechanical moldings and carvings, as our ancestors used to spoil the looks of steam radiators and cooking ranges. That is sentimental nonsense: the canons of machine art are precision, economy, slickness, severity, restriction to the essential, and whenever these canons are violated—either by the application of irrelevant ornament or by packaging the works in an irrelevant form,

streamlining pencil sharpeners or other stationery objects, for example, or making the radiator of an automobile look like the mechanical counterpart of a shark's mouth, or accentuating speed, as another motor car designer tries to, by turning what should be a protective molding into a chromium arrow—when this sort of thing is done the result is not the humanization of the machine but its debasement. It does not thereby acquire human values; it merely loses important mechanical values, values which, by their proper esthetic expression, do have at least a modicum of human relevance, to the extent that they express order or subserve power. The point is that the machine is not a substitute for the person; it is, when properly conceived, an extension of the rational and operative parts of the personality, and it must not wantonly trespass on areas that do not belong to it. If you fall in love with a machine there is something wrong with your love-life. If you worship a machine there is something wrong with your religion.

One of the effects of the machine arts is to restrict the area of choice, on the part of the designer, and to extend the area of influence, with respect to the product. In some sense, man must forgo his purely personal preference and submit to the machine before he can achieve good results in the limited province of choice that remains to him. This curtailment of freedom is not unknown even in the pure arts: the sonnet, or any other strict form in any of the arts, the fugue say in music, sets similar boundaries to personal expression, and the sculptor, too, must follow the grain of the wood or respect the quality of the stone if he is to get the best results from his work; material and process play this part everywhere.

What is peculiar to the machine is that choice, freedom, esthetic evaluation, are transferred from the process as a whole, where it might take place at every moment, to the initial stage of design. Once choice is made here, any further human interference, any effort to leave the human imprint, can only give impurity to the form and defeat the final result. So it is by a fine sense of formal relationships, by proportion, by rhythm, by delicate modulation of the utilitarian function that good form is achieved in the machine arts: this applies equally to a page of type or to a bridge, to a chair or a pitcher. In the case of photography, for example, there was for long a question as to whether it was or was not art. And the answer to that question is: Is there any leeway for choice and initiative on the part of the photographer? If there is such leeway, there is a possibility of art; that is, of success or failure in terms that would have significance to the beholder. Perhaps the best effect of machine art is to make us conscious of the play of the human personality in the small area where it remains free, a differentiation so delicate, so subtle, that a coarse eye would hardly take it in and an insensitive spirit would not know what it meant. The artists who have taught us most about the values of the machine in our day—I would single out particularly Alfred Stieglitz, Brancusi and Naum Gabo—have been remarkable for this exquisite touch, for this sense of a perfection in form achieved by leaving the minimum human imprint on a natural form or a purely geometrical shape; so it was by the slightest modulation of an ovoid piece of marble that Brancusi turned an egg into a human head. Henry James, in that wonderful story "The Great Good Place," dreamed of an architecture "all

beautified by omissions"; and that effort to rid itself of the superfluous, to return to the essential and the inevitable, is one of the truly esthetic qualities of machine art, one that indicates the maximum determination by human values. Once that delicacy of perception becomes common, we shall not have to worry so much about the problem of quantification: for within the machine itself we shall have some of the intense interest in qualities, and in the effect of qualities upon the human mind, that came so naturally with earlier forms of art and handicraft. That problem of quantification, however, is a specially serious one; and I shall need the whole of the next lecture to put it before you.

Once we have achieved the right form for a type-object, it should keep that form for the next generation, or for the next thousand years. Indeed, we should be ready to accept further variations only when some radical advance in scientific knowledge, or some radical change in the conditions of life has come about—changes that have nothing to do with the self-indulgent caprices of men or the pressures of the market. Then, and then only, does a modification of the type become imperative. Otherwise the ideal goal for machine production is that of a static perfection, a world of immobile platonic forms, as it were, a world of crystalline fixity, rather than of continued change and flux. The more automatic our processes become, and the more heavy the investment in automatic equipment, the more in fact does this tendency toward the static actually hold. Today, for example, the change-over from our present system of telephone dialing to a quicker one, now technically possible, which would use push buttons, is retarded by the staggering expense

of making this adaptation. Therein lies the paradox of technical progress.

This interpretation of the path of technics, as leading to a series of flat plateaus rather than as a steady climb upward, is, I know, a baffling contradiction to the popular one. Indeed it must seem another perilous heresy. The animus of the last three centuries has been toward improvement, innovation, invention without end; and the chief duty of man, according to the utilitarian catechism, is to adapt himself to such mechanical changes as rapidly as is necessary to make them profitable. But this stale view assumes that we are capable of learning nothing, that we are incapable of mastering the machine we have created and putting it in its place; that we shall not emancipate ourselves from the manias and compulsions that our preoccupation with the machine has brought into existence; that philosophy and religion and art will never again open up to man the vision of a whole human life. It assumes indeed that we shall never call our soul our own again. But once we arrive at a fuller degree of self-understanding, we shall render unto the machine only that which belongs to the machine; and we shall give back to life the things that belong to life: initiative, power of choice, self-government—in short, freedom and creativeness. Because man must grow, we shall be content that the machine, once it has achieved the power and economy of a good type, should stand still— at least until the creator again places himself above the level of his mechanical creature. If this is too much to expect, then the time has come to set the stage for Post-Historic Man: the man without memory or hope.

Standardization, Reproduction
and Choice

THE PROBLEM that I now propose to discuss is one that goes far beyond the realm of art itself; and I do not mean to let myself be unduly confined, in endeavoring to carry that problem to its conclusions. But the problem arose, perhaps earlier than anywhere else, in the domain of art, and I am grateful that the general scope of these lectures encourages me to draw most of my illustrations from the related fields of technics and the arts. As far as time allows, I shall follow the trail opened in the arts into the rest of life; and if I do not take you the full distance, you will at least have provisions of a modest kind for making the journey by yourselves. We have seen, so far, that the split between art and technics, which is such a vexing one in our life today, perhaps existed from the very beginning of their development: that Prometheus and Orpheus, if in a sense brothers, were also like Cain and

Abel bitter rivals, and that only in the more fortunate epochs of civilization were the two sides of life they represented fully reconciled.

But not least among the many paradoxes that greet us in the relations of art and technics is the fact that the process of quantification was, from an early time, applied particularly to works of art. Casting and molding and stamping are all of them very old technical devices: they are devices whereby, with a standard pattern or form, one can reproduce innumerable exact copies of the original work. At a time when the sanitation system of Athens would have disgraced a second-rate American country town, at a time when wheat was ground largely in hand querns, the process of reproduction by casting was applied with great success to statues. All this is in line with what I was saying in my last lecture; namely, that the first step in modern mass production—and so ultimately in the creation of our depersonalized, quantity-minded world today—took place when the almost equally ancient stamping process was applied to the mechanical reproduction of images, by means of wood-block printing. Though the first use for this adroit invention, it would seem, was the printing of playing cards—a characteristic contribution to the new spirit of gambling that went along with the early development of capitalism—the next use was the general making of pictures for wide distribution.

Just as the typographer took over from the calligrapher or copyist the more standardized part of his art, the printed letter, so the maker of woodcuts took over from the illuminator the freer and more imaginative part of his art, that associated with the image. This effort to

multiply and cheapen the means of reproducing pictures resulted in a remarkable series of inventions during the next five centuries. First, of course, wood-block printing: this was followed by copper and steel engraving, which served so well the new map makers and cartographers, helping to produce maps of unrivaled clarity and sharpness of line: this, again, was followed by various forms of etching, using chemical as well as mechanical processes, which enabled artists like Rembrandt to produce prints qualitatively different from those that a pencil or a pen could produce. Finally, the invention of the lithograph multiplied the facilities of the pencil. Along another line, beginning with the invention of the colored woodcut in 1508, there was a parallel growth, which led eventually to color lithography and later forms of photographic color reproduction. Even though there might be no increase in the technical mastery or the esthetic exploitation of the new media, the mechanical processes of reproduction were facilitated and extended. Along with this mass production of art, people tended to become more picture-minded; or rather, perhaps, they were confirmed in their original picture-mindedness.

To understand the bearings of this change we must realize that it was at once a technical innovation, a social device, a means of popular education, and a way by which the monopoly of art by a small group was broken down. With the invention of graphic reproduction, pictures could go into circulation like any other commodity; they could be sold at markets and fairs so cheaply that all but the poorest classes could afford to own them. Sometimes these early prints were the media of popular realistic education, as in Jost Ammann's noted series on

the crafts and occupations; sometimes they served as improvised newssheets to record remarkable or fantastic events; sometimes, at a later day, they would be used by Hogarth to point moral lessons or by Rowlandson to satirize the very middle class that was buying his pictures.

From the fifteenth century onward, the picture was not merely something that you saw, in the form of tapestry, on the walls of a castle, or in the form of a fresco or an oil painting in a church or palace: in the cheap medium of an engraving it could be carried home; and so, in a sense, what it lost in uniqueness it gained in intimacy and variety and wide distribution. As long as good examples still abounded on the higher levels of art, these vulgar reproductions retained many of the virtues of original painting. If they lacked pretentiousness, they gave to the unpretentious moments, the common occupations, the daily scene, the common pastimes, the dignity of being sufficiently memorable to be preserved. That was a victory for democracy, achieved in the arts long before its proposition, that all men are created equal, was put forward in politics.

This democratization of the image was one of the universal triumphs of the machine, as well as one of the earliest. So deep and widespread was its influence that it took place even in countries like Japan, where all the dominant patterns of society remained feudal and caste-limited; and, as in Europe, the method and the spectator's interest affected the content of the print, too. Long before mechanization had taken command of transportation and textile production, it freed the image for popu-

lar consumption and produced new images in large
quantities.

Viewed in its beginnings, this whole process, like that
of democracy itself, seems an entirely happy one. If art
is good, then surely it is good for everyone. If painting
and carvings are means whereby people become con-
scious of feelings, perceptions, interests that would other-
wise be unexpressed or unformed, then why should not
prints of all kinds perform the same office, in some degree
to supplement the functions of collective art, as people
viewed it habitually in their public buildings, civic and
religious? If one does not in this minor form of art always
reach the high and exalted level of public art, why should
there not be a place for a less high-flown kind of esthetic
response, fit to take its place, with its slippers on, before
the domestic fire? In one age the Tanagra figurine; in
another the woodcut. That there was something in the
machine process itself that might, if people were un-
guarded, make this excellent development go dreadfully
awry was a possibility that hardly anybody began to sus-
pect before the nineteenth century.

Meanwhile, as the technical processes of reproduction
were being invented and perfected, as mass distribution
in the graphic arts was becoming ever more feasible,
something had been happening of the same order within
the domain of the symbol itself. The turning of interest
away from the self and toward the object we associate
with the growth of realism in late medieval and renas-
cence painting. That change manifested itself in a variety
of ways. One of them was the devaluation of traditional
symbols. Thus, for one thing, the austerely divine Virgin

of fourteenth century painting becomes the soft-curved doting mother of sixteenth century painting, that all too human creature: the subject ostensibly remains the same, but the descent from heaven to earth is swift. Or again, take Breughel the Elder's paintings, almost any of his figure paintings, but above all his interpretation of Christ bearing his cross to Calvary. That is in a sense one of the first bugle blows of democracy: it proclaimed liberty, equality, and fraternity more loudly than the French Revolution itself: above all, equality. For at first one looks all over the painting for the principal figure, only to find that, in the artist's perspective, there *is* no principal figure: Jesus himself is lost in a swarm of other figures and can be found only after some searching in the middle distance. One must take an imaginary ruler and draw intersecting lines from the four corners of the picture to find that Jesus occupies the mathematical— though not the visual—center of this space. Breughel, in his very method of composition, repeatedly proclaims the equality of all ranks; and the painters after him carried that leveling of persons a stage further toward the now depersonalized world of science by finding that the costume was more important than the human face, or that the landscape was more significant than the figures in it. In the end this led to the reduction of the artist into a mere transcriber of nature: a register of optical sensation: a blank surface on which images left a mark. What the Dutch realists began, the painters of the nineteenth century carried to a theoretic conclusion; and the results may be summarized by two characteristic remarks. Claude Monet, Cézanne observed, was only an eye:

but what an eye! Gustave Courbet said that he did not paint angels because he had never discovered any in nature. From these remarks one could draw two conclusions: the painter had become a specialist in sense-data; and the only world he knew was that which was external to him. Those remarks might have been enough to persuade any cultural historian that a development was about to take place in painting similar to that which had taken place in printing; and he would not have been wrong. As a matter of fact that change had already taken place even before Monet and Courbet and the other nineteenth century realists had started to paint.

As far as realism could go in search of visual matter-of-factness the seventeenth century Dutch realists had already gone. By conscientious effort they had produced the color photograph, in fact the best color photographs that have yet been made. The exquisite perfection of these handmade photographs has never been excelled, as yet, by any product of the machine. As with the manuscript copyist, their process was laborious; and in order to rival it by mechanical means, it was first necessary to simplify it, by reducing it to black and white. The original step toward this end was taken at a very early date— 1558—by Daniello Barbara who invented a camera and stop for the diaphragm. The next step awaited the further development of chemistry; and it therefore could hardly have taken place till the nineteenth century. At length, in the 1830s, it occurred to two independent inventors, Talbot and Niepce, that the abstract office performed by the realist painter's eye could also be performed by a simple apparatus that would throw the light rays from

the outside world upon a chemically sensitized surface. With the invention of photography the process of depersonalization came to a climax.

Now, by perfecting a mechanical method, the "taking of pictures" by a mere registration of sensations was democratized. Anyone could use a camera. Anyone could develop a picture. Indeed, as early as the 1890s the Eastman Company went one step further in the direction of automatism and mass production, by saying to the amateur photographer—this was their earliest advertising slogan—*You press the button, we do the rest.* What had been in the seventeenth century a slow handicraft process, requiring well-trained eyes and extremely skilled hands, with all the rewards that accompany such highly organized bodily activities, now became an all-but-automatic gesture. Not entirely an automatic gesture, I hasten to add, lest any photographers in this audience should squirm in agonized silence or break forth into a loud shout of protest. For after all it turns out that even in the making of the most mechanically contrived image, something more than machines and chemicals is involved. The eye, which means taste. The interest in the subject and an insight into the moment when it—it or he or she—is ready. An understanding of just what esthetic values can be further brought out in the manipulation of the instrument and the materials. All these human contributions are essential. As in science, no matter how faithfully one excludes the subjective, it is still the subject who contrives the exclusion. All this must be freely granted. But this is only to say that in photography another machine art like printing was born; and that the standards of esthetic success in this art are not dissimilar

to those in printing. If we consider those standards for a moment we shall have a clue to one of the most essential problems connected with automatism and reproduction.

As with printing, photography did not altogether do away with the possibilities of human choice; but to justify their productions as art there was some tendency on the part of the early photographers, once they had overcome the technical difficulties of the process, to attempt to ape, by means of the camera, the special forms and symbols that had been handed down traditionally by painting. Accordingly, in the nineties, American photographs became soft and misty and impressionistic, just when impressionism was attempting to dissolve form into atmosphere and light. But the real triumphs of photography depended upon the photographer's respect for his medium, his interest in the object before him, and his ability to single out of the thousands of images that pass before his eye, affected by the time of day, the quality of light, movement, the sensitivity of his plates or film, the contours of his lens, precisely that moment when these factors were in conjunction with his own purpose. At that final moment of choice—which sometimes occurred at the point when a picture was taken, sometimes only after taking and developing a hundred indifferent prints—the human person again became operative; and at that moment, but only at that moment, the machine product becomes a veritable work of art, because it reflects the human spirit.

As far as its effect upon painting went, the first result of photography, perhaps, was to increase the danger of technological unemployment; for if the painter were

only an eye, the camera's eye was not merely his equal but, in many respects, his superior. While painters themselves were among the first to exploit the possibilities of the new art—Octavius Hill, the great Edinburgh photographer, for example, went into photography in order to get a record of a large group of clergymen he wished to work into a group portrait—the inevitable result of this art was to devaluate mere realism. Wealthy patrons might continue to employ the painter because his images, being handmade, were rarer and more obviously expensive. But in the end, if the artist did not have something to say that could not be recorded by mechanical means, he and his tedious handicraft process were ready for the scrap heap. On the level of mere visual abstraction—for of course a photograph, accurate and realistic, is an abstraction from the multidimensional object it interprets—there was nothing more for the painter to do. As against a single person who could use a brush passably, there were thousands who could take reasonably good photographs. Here the first effect of the machine process was to deliver people from the specialist and to restore the status and function of the amateur. Thanks to the camera, the eye at least was reeducated, after having been too long committed to the verbal symbols of print. People awoke to the constant miracles of the natural world, like an invalid long secluded in a dark room, able for the first time to breathe the fresh air and feel the sunshine, grateful for the simplest play of light and shade over the landscape. But though the art of taking pictures is necessarily a selective one, the very spread and progress of that art, not least with the invention of the motion picture, was in the opposite direction: it

multiplied the permanent image as images had never been multiplied before, and by sheer superabundance it undermined old habits of careful evaluation and selection. And that very fact, which went along with the achievement of a democratic medium of expression, has raised a whole series of problems that we must wrestle with today, if, here as elsewhere, we are not to starve in the midst of plenty.

This brief review of the course of the reproductive processes in art, from the wood engraving to the colored lithograph, from the photographic painting to the photograph proper, capable of being manifolded cheaply, does not take into account various subsidiary efforts in the same direction in many of the other arts, such as the reproduction of sounds, by means of the phonograph and the talking film; to say nothing of the fortunately abortive efforts of James Watt to find a mechanical means of reproducing, in the semblance of sculpture, the human form, an effort on which the inventor of the steam engine curiously wasted some of the best years of his life. I have filled in this background briefly merely in order to prepare the way for discussing the results of these many efforts to multiply the symbol, and so to deal with the problem of assimilation.

What has been the result of the mass production of esthetic symbols that began in the fifteenth century? What benefits have we derived from it and what dangers do we now confront? With your permission, I shall speak only briefly about the benefits, since we are all conscious of them. By means of our various reproductive devices, a large part of our experience, which once vanished without any sort of record, has been arrested and fixed. Be-

cause of the varied processes of reproduction that are
now at hand, many important experiences, difficult to
transpose into words, are now visible in images; and
certain aspects of art, which were once reserved for the
privileged, are now an everyday experience to those who
make use of the resources of printing and photography.
The gains from these processes are so demonstrable that
we have, unfortunately, become a little unwary as to the
deficits and losses; so I purpose now to point out how
our very successes with the reproductive arts present us
with a problem whose dimensions have been increasing
at almost geometric ratio, year by year.

The fact is that in every department of art and thought
we are being overwhelmed by our symbol-creating ca-
pacity; and our very facility with the mechanical means
of multifolding and reproduction has been responsible
for a progressive failure in selectivity and therefore in
the power of assimilation. We are overwhelmed by the
rank fecundity of the machine, operating without any
Malthusian checks except periodic financial depressions;
and even they, it would now seem, cannot be wholly
relied on. Between ourselves and the actual experience
and the actual environment there now swells an ever-
rising flood of images which come to us in every sort of
medium—the camera and printing press, by motion
picture and by television. A picture was once a rare sort
of symbol, rare enough to call for attentive concentra-
tion. Now it is the actual experience that is rare, and the
picture has become ubiquitous. Just as for one person
who takes part in the game in a ball park a thousand
people see the game by television, and see the static
photograph of some incident the next day in the news-

paper, and the moving picture of it the next week in the newsreel, so with every other event. We are rapidly dividing the world into two classes: a minority who act, increasingly, for the benefit of the reproductive process, and a majority whose entire life is spent serving as the passive appreciators or willing victims of this reproductive process. Deliberately, on every historic occasion, we piously fake events for the benefit of photographers, while the actual event often occurs in a different fashion; and we have the effrontery to call these artful dress rehearsals "authentic historic documents."

So an endless succession of images passes before the eye, offered by people who wish to exercise power, either by making us buy something for their benefit or making us agree to something that would promote their economic or political interests: images of gadgets manufacturers want us to acquire; images of seductive young ladies who are supposed, by association, to make us seek other equally desirable goods, images of people and events in the news, big people and little people, important and unimportant events; images so constant, so unremitting, so insistent that for all purposes of our own we might as well be paralyzed, so unwelcome are our inner promptings or our own self-directed actions. As the result of this whole mechanical process, we cease to live in the multidimensional world of reality, the world that brings into play every aspect of the human personality, from its bony structure to its tenderest emotions: we have substituted for this, largely through the mass production of graphic symbols—abetted indeed by a similar multiplication and reproduction of sounds—a secondhand world, a ghost-world, in which everyone lives a second-

hand and derivative life. The Greeks had a name for this
pallid simulacrum of real existence: they called it Hades,
and this kingdom of shadows seems to be the ultimate
destination of our mechanistic and mammonistic culture.

One more matter. The general effect of this multipli-
cation of graphic symbols has been to lessen the impact
of art itself. This result might have disheartened the
early inventors of the new processes of reproduction if
they could have anticipated it. In order to survive in
this image-glutted world, it is necessary for us to de-
valuate the symbol and to reject every aspect of it but
the purely sensational one. For note, the very repetition
of the stimulus would make it necessary for us in self-
defense to empty it of meaning if the process of repeti-
tion did not, quite automatically, produce this result.
Then, by a reciprocal twist, the emptier a symbol is of
meaning, the more must its user depend upon mere
repetition and mere sensationalism to achieve his pur-
pose. This is a vicious circle, if ever there was one. Be-
cause of the sheer multiplication of esthetic images,
people must, to retain any degree of autonomy and
self-direction, achieve a certain opacity, a certain in-
sensitiveness, a certain protective thickening of the hide,
in order not to be overwhelmed and confused by the
multitude of demands that are made upon their atten-
tion. Just as many people go about their daily work, as
too often students pursue their studies, with the radio
turned on full blast, hearing only half the programs, so,
in almost every other operation, we only half-see, half-
feel, half-understand what is going on; for we should be
neurotic wrecks if we tried to give all the extraneous
mechanical stimuli that impinge upon us anything like

our full attention. That habit perhaps protects us from an early nervous breakdown; but it also protects us from the powerful impact of genuine works of art, for such works demand our fullest attention, our fullest participation, our most individualized and re-creative response. What we settle for, since we must close our minds, are the bare sensations; and that is perhaps one of the reasons that the modern artist, defensively, has less and less to say. In order to make sensations seem more important than meanings, he is compelled to use processes of magnification and distortion, similar to the stunts used by the big advertiser to attract attention. So the doctrine of quantification, Faster and Faster, leads to the sensationalism of Louder and Louder; and that in turn, as it affects the meaning of the symbols used by the artist, means Emptier and Emptier. This is a heavy price to pay for mass production and for the artist's need to compete with mass production.

Behold, then, the so-far-final result of our magnificent technical triumphs in the reproductive arts. We diminish the contents of the image: we narrow the human response: we progressively eliminate the powers of human choice: we overwhelm by repetition, and, in order to stave off boredom, we have to intensify the purely sensational aspects of the image. In the end, the final effect of our manifold inventions for manifolding is to devaluate the symbol itself; partly because it comes to us, as in a tied-in sale, attached to some other object which we may or may not want; partly because it has multiplied to such a point that we are overwhelmed by sheer quantity and can no longer assimilate anything but a small part of the meaning it might otherwise convey. What

is responsible for this perversion of the whole process of reproduction? Something we should have been aware of from the beginning. We have gratuitously assumed that the mere existence of a mechanism for manifolding or mass production carries with it an obligation to use it to the fullest capacity. *But there simply is no such necessity. Once you discover this, you are a free man.*

I speak with some feeling on this subject, and a little experience, because for the better part of a summer I was annoyed by a loud-speaker operated by a neighbor of mine who runs a small summer hotel and who had installed this formidable instrument for the entertainment of his guests. He is a thoroughly nice man, with whom I am on very neighborly terms, and he merely thought to provide all the benefits of modern science for his temporarily rusticated urban clients. Unfortunately, though I am a quarter of a mile away, the sounds of his loud-speaker blared into my small study, as insistently as a drunken man shouting in my ear. It took weeks of vexing argument and tactful persuasion to drive home to him two simple principles: first, just because a loud-speaker is called loud, it needn't be turned on at its loudest volume in order to fulfill its mission; second, just because a machine can be on duty twenty-four hours, that is no reason for keeping it operating on that schedule. The great principle here is that as soon as mechanical limitations are thrown off, human restrictions must be clamped on. I trust that this argument will prove as convincing to this audience as it did to my neighbor; for his loud speaker is now so inaudible that I begin to fear he has gotten rid of it altogether. But that would unfortunately mean that he had not really grasped

my point; for I was pleading, not for abolition of the machine, but for its effective control.

Now let me carry this general argument about the devaluation of the image back into the realm of art. One of the real achievements of technics during the last half century has been to devise means of making color reproductions of pictures with increasingly high fidelity. Where sufficient care and craftsmanship is used, in the gelatine process, it is possible, at least in the case of pen drawings and water colors and sepia washes, to reproduce pictures so faithfully that the artist himself has often mistaken the reproduction for the original work. As a result, for a small fraction of the price of an original painting—itself sometimes priceless and beyond the means of even the wealthiest bidder—the ordinary citizen may have, as his private possession, a picture that in its original form was entirely beyond his reach, physically as well as financially. On the surface this seems an unalloyed triumph for the mechanical process. Does it not, in no small degree, atone for the devaluation of the esthetic symbol in other departments? In one sense, this actually *is* a genuine triumph for popular education, for it is capable of fulfilling the otherwise demagogic promise of making every man a king, even as it in some degree reduces the king—the proud possessor of a unique object—to the level of the man in the street.

As with the entire democratic process of equalization, that process which de Tocqueville described as the essential theme of the last seven centuries, mechanization brings about a true leveling off in both directions, upward and downward: fair esthetic shares for all, as the British could say. But what, if you look closer, is the *actual* re-

sult? Thanks to our confirmed habits of *non*-selectivity the outcome is not quite so happy as one might fancy. The actual result is that already, in big cities at least, there is a whole group of great pictures, so frequently reproduced, so often hung, so insistently visible, that they have forfeited, no matter how faithful the reproduction, all the magic of the original. We all have seen these pictures, but alas, once too often. When I was a boy such a picture was Sir Luke Fildes' painting of the benign bewhiskered physician visiting a sick child, a bathetic piece of popular art, whose devaluation would now bring tears to no one's eye. But the same thing is happening again, because of the very raising of the level of popular taste, with paintings of the highest excellence. There are paintings by Van Gogh and Matisse and Picasso that are descending the swift slippery slope to oblivion by reason of the fact that they are on view at all times and everywhere. And whereas, with every great work of art, the more one returns to it the more one sees in it, once one has reached a certain point of super-saturation, the result is the rapid effacement of the image: it sinks into the background: indeed, it disappears.

Mind you, I am not speaking about the effect of poor and inadequate reproductions of paintings; though of these unfortunately there is a terrifying abundance. I have seen reproductions of great paintings on view in famous museums of art that reflect on either the sound eyesight or the elementary honesty of their curators and directors, so false was every value and color to the original. So, too, I have looked into textbooks on art, prepared for elementary schools, in which bad pictures paraded as high art, and in which good pictures were so vilely re-

produced that they constituted an esthetic betrayal of both the artist and the student. Our coarseness of discrimination here, indeed our absence of decent morals, is disquieting. But the vice I am now speaking about is quite different from these misdemeanors. Even when our reproductions are adequate, even when they are marvelously good, near to being perfect, we must still confront one very significant fact that our whole civilization seems, in its preoccupation with mechanical competence, to have long lost sight of. My elders used to put it, somewhat smugly as it seemed when I was young, by saying that it was possible to have too much of a good thing. But the long experience of the race stands behind that dictum: It *is* possible to have too much of a good thing; and indeed, the more intense, the more valuable an experience is, the more rare it must be, the more brief its duration. One could perhaps sum this up by saying that a blessing, repeated once too often, becomes a curse. Now, regularity and repetition, those gifts of the machine, must be confined to those parts of life that correspond to the reflex system in the body; they are not processes that have anything to contribute, except in a strictly subordinate way, to the higher functions, to the emotions and imagination, to esthetic feelings and rational insight. The danger of an overregulated, overroutinized life, given to excessive repetition, was long ago discovered in the monastery. It produces the special vice called *acedià,* or abysmal apathy. Any object that is too constantly present, however interesting or desirable it may be in itself, presently loses its special significance; what we look at habitually, we overlook. Gilbert Chesterton used that perception in one of his Father Brown

stories, in which the murder was committed by the post-
man. No one suspected the postman, indeed no one *saw*
him come to the house at the hour the crime was com-
mitted, precisely because that was his usual time for
making his usual rounds. His very constancy put him
completely out of the minds of the witnesses. So, per-
haps, many a man has fallen for the lure of another
woman, not his wife, not because her charms were neces-
sarily in any way superior, but because he has actually
ceased to observe, and so ceased to respond to, the
charms that his mate too habitually exposed to him; and
the very irregularity and unexpectedness of his new rela-
tions gave them a disproportionate attraction. This gen-
eral truth about constancy and repetition has a direct
application to reproduction and domestication in art.
Novelty, adventure, variety, spontaneity, intensity—
these are all very essential ingredients in a work of art;
and a great work of art, like El Greco's *Toledo* at the
Metropolitan, is one that presents this feeling of shock
and delight, of new things to be revealed, at every en-
counter with it. Such works are inexhaustible in their
meaning. But with one proviso: one must not go to them
too often. The rarity of the experience is an essential
preparation for the delight. Without rhythm and interval
there is only satiation and ennui.

But all this in opposition to the tendency of mass pro-
duction. Mass production imposes on the community a
terrible new burden: the duty to constantly consume.
In the arts, at the very moment the extention of the repro-
ductive processes promised to widen the area of freedom,
this new necessity, the necessity to keep the plant going,
has served to undermine habits of choice, discrimination,

selectivity that are essential to both creation and enjoyment. Quantity now counts for more than quality. There used to be an old popular song with the words, "I'll try anything once, if I like it I'll try it again." But under the machine system, you'll not only try it again, you'll try it a thousand times, whether you like it or not, and a vast apparatus of propaganda and persuasion, of boasting and bullying, will coerce you into performing this new duty.

You know the old fable of the Sorcerer's Apprentice, which Goethe thought it worth while to put into verse, and which has even, in our time, gotten into the animated cartoon: the clever apprentice who repeated the old sorcerer's spell and got the pail and the broom to do his work for him, when the master was away, while he stayed idle. Unfortunately, though he knew how to bring into existence a whole regiment of pails and brooms, which went about their work with unflagging automatic energy, he had never mastered the formula for bringing their activities to an end: so presently he found himself floundering in a flood of water that these self-willed pails were pouring into his master's house. So with the apprentices to the machine. We not merely encourage people to share the new-found powers that the machine has opened up: we *insist* that they do so, with increasingly less respect for their needs and tastes and preferences, simply because we have found no spell for turning the machine off. The grim fable of the Sorcerer's Apprentice applies to all our activities, from photographs to reproduction of works of art, from motor cars to atom bombs. It is as if we had invented an automobile that had neither a brake nor a steering wheel, but only an accelerator, so that our sole form of control consisted in making the machine go

faster. For a little while, on a straight road, we might feel safe, and even, as we increased our speed, gloriously free; but as soon as we wanted to reduce our speed or to change our direction or to back up, we should find that no provision had been made for this degree of human control—the only open possibility was *Faster, faster!* As our mass-production system is now set up, a slowing down of consumption, in any department, produces a crisis if not a catastrophe. That is why only under the pressure of war or preparation for war, in which wholesale waste and destruction come to its aid, does the machine, as now conceived, operate effectively on its own terms.

The tendencies I have been describing are, you will recognize, universal ones; but in no realm have they been more fatal than in the realm of art. As long as a work of art was an individual product, produced by individual workmen using their own feeble powers with such little extra help as they could get from fire or wind or water, there was a strict limit to the number of works of art that could be produced in a whole lifetime, whether they were paintings or statues, woodcuts or printed cottons. Under such a system of production there was no problem of quantity; or, rather, the problem was that of too little, not too much. Natural and organic limitations took the place of rational selectivity. Only those who exercised some special political or economic monopoly were ever even temporarily in a position of being threatened by a surfeit; and so the appetites remained keen, because only rarely could they be sated. Under such conditions, there was little reason to exercise a vigilant control over quantity, for fostering a discipline of restraint and a habit of

studious selection; such discrimination as was necessary was that exercised on a basis of quality alone.

What has happened during the last century has brought about just the opposite kind of condition. As a result of our mechanical reproductive processes, we are now creating a special race of people: people whom one may call art-consumers. From earliest youth they are trained to conduct the normal activities of living within the sound of the radio and the sight of the television screen; and to make the fullest use of our other facilities for reproduction, they are taken, in all big cities at least, in troops and legions through the art galleries and museums, so that they may be conditioned, with equal passivity, to the sight of pictures. The intimate experiences, the firsthand activities, upon which all the arts must be based are thrust out of consciousness: the docile victims of this system are never given enough time alone to be aware of their own impulses or their inner promptings, to indulge in even so much as a daydream without the aid of a radio program or a motion picture; so, too, they lack even the skill of the amateur to attune them more closely to the work of art.

Those who have pushed the reproductive processes to their limit, forget the essential nature of art: its uniqueness. While a certain kind of order and form should prevail in the background of all activities, esthetic interests that promote any intensity of stimulus and meaning must necessarily be of short duration. The fact is that our reproductive facilities in the arts will be of human value, only when we learn to curb the flood of images and sounds that now overwhelm us, until we control the occasion, the quantity, the duration, the frequency of repe-

tition, in accordance with *our* needs, with *our* capacity
for assimilation. These are the saving imperatives of an
age that has made the fatal error of the Sorcerer's Ap-
prentice. Expressive art, just in proportion to its value
and significance, must be precious, difficult, occasional,
in a word aristocratic. It is better to look at a real work
of art once a year, or even once in a lifetime, and really
see it, really feel it, really assimilate it, than to have a
reproduction of it hanging before one continually. I may
never, for example, see the Ajanta cave paintings. From
reproductions, as well as from travelers who have been
in India, I well know that these paintings are worth see-
ing; and if ever I make the journey I expect to carry away
a unique impression, reinforced by the strange faces, the
different languages and customs, I shall meet on my
pilgrimage. But better a few short hours in the cave, in
direct contact with the work of art itself, than a lifetime
in looking at the most admirable reproductions. Though
here, as in many other places, I shall be grateful for the
mechanical reproduction, I shall never deceive myself
by fancying that it is more than a hint and a promise of
the original work.

Or take, for another example, the intense enjoyment
of solitude in nature, in a noble grove of trees or on a
high mountain top. No small part of that particular ex-
perience comes from the fact that only a few human
souls are present at any moment. This is what adds the
last edge of esthetic significance and emotional stimulus
to the experience. If you cut a three-lane highway to the
top of that mountain and bring five thousand people to
enjoy the solitude, the very essence of the experience
is gone: it is replaced by something else, the gregarious
good nature, the commonplace sociability, of five thou-

sand people, meeting on a mountain top instead of a city park, but with little sense of nature and with no sense of cosmic isolation.

Thus I come to the final point and moral of this lecture. The quantitative reproduction of art, through the advance of technics, from the woodblock print to the wire-recording phonograph, has increased the need for qualitative understanding and qualitative choice. At the same time it has imposed upon us, in opposition to the duty to participate in mass consumption, the duty to control quantity: to erect rational measures and criteria of value, now that we are no longer disciplined by natural scarcity. The very expansion of the machine during the last few centuries has taught mankind a lesson that was otherwise, perhaps, too obvious to be learned: the value of the singular, the unique, the precious, the deeply personal. There are certain occasions in life when the aristocratic principle must balance the democratic one, when the personalism of art, fully entered into, must counteract the impersonalism, and therefore the superficiality, of technics. We do no one any service, with our reproductive processes, if we limitlessly water the wine in order to have enough to give every member of the community a drop of it, under the illusion that he is draining an honest glass. Unless we can turn the water itself into wine, so that everyone may partake of the real thing, there is in fact no miracle, and nothing worth celebrating in the marriage of art and technics. On the other hand, if we establish this personal discipline, this purposeful selectivity, then nothing that the machine offers us, in any department, need embarrass us.

This conclusion should go some distance in repairing the breach that has so long existed between art and

morals, between goodness and truth. The fact is that to enjoy the perfections and delights of art, above all in a day of mass production, the whole organism must be keyed up to its highest level of vigor, sensitive and responsive as only healthy beings are sensitive and responsive; and to achieve this state requires not only hygiene and gymnastic, as the incomparable Athenians knew, but a high state of moral alertness and conscious control. This means, finally, a readiness to reject many inferior goods in favor of the supreme good offered by a genuine work of art, which is like the blessing of friendship, when offered by a person who gives you his best without reserves.

To control the quantitative flood that our mischievous Sorcerer's Apprentices have turned loose, we need to develop habits of inhibition on which we too glibly have bestowed, in the recent past, the epithet puritanic. You will not accuse me, if you have heard these earlier lectures, of being anything but a fervent admirer of William Blake; but for all that I would amplify one of his aphorisms—Damn Braces, Bless Relaxes—and would say that there is no chance of coping with the evils of mass production unless we are likewise ready to bless braces and to exercise, whenever needed, the most strenuous control of mere quantity. To have the right amount of the right quality in the right time and the right place for the right purpose is the essence of morality; and as it turns out, it is perhaps the most important condition for the enjoyment of art. Here if anywhere, Nietzsche's words, as uttered by Zarathustra, actually hold: "Choosing is creating." Yes: choosing is creating. "Hear that, ye creating ones!"

Symbol and Function
in Architecture

IN OUR DISCUSSION OF art and technics so far, I have—
not entirely by accident—kept away from the one great
domain where, in the very nature of things, they have
always been united in the closest sort of domestic union;
though as often happens even in very close and affec-
tionate families, this union has not been altogether de-
void of conflict. I am speaking, of course, of architecture.
In that art, beauty and use, symbol and structure, mean-
ing and practical function, can hardly even in a formal
analysis be separated; for a building, however artless,
however innocent of conscious speech on the part of the
builder, by its very presence cannot help saying some-
thing. Even in the plainest esthetic choices of materials,
or of proportions, the builder reveals what manner of
man he is and what sort of community he is serving. Yet
despite this close association in building between tech-

nics and art, doing and saying, the separate functions are clearly recognizable in any analysis of an architectural structure: the foundations, the inner drainage system, or in later days the heating and cooling systems, plainly belong exclusively to technics; while the shape and scale of the structure, the elements that accentuate its function or emphasize its purpose in order to give pleasure and sustenance to the human spirit, is art.

On one side there is the engineering side of building: a matter of calculating loads and stresses, of making joints watertight and roofs rainproof, of setting down foundations so solidly that the building that stands on them will not crack or sink. But on the other side there is the whole sphere of expression, the attempt to use the constructional forms in such a way as to convey the meaning of the building to the spectator and user, and enable him, with a fuller response on his own side, to participate in its functions—feeling more courtly when he enters a palace, more pious when he enters a church, more studious when he enters a university, more businesslike and efficient when he enters an office, and more citizenlike, more cooperative and responsible, more proudly conscious of the community he serves, when he goes about his city and participates in its many-sided life. Architecture, in the sense that I here present it to you, is the permanent setting of a culture against which its social drama can be played out with the fullest help to the actors. Confusion and cross purposes in this domain—such confusion as has existed in the recent past when businessmen thought of their offices as Cathedrals, or when pious donors treated university buildings as if they were private mausoleums—all this brings about dis-

ruption in our life; so that it is of utmost importance that symbol and function in architecture should be brought into an effective harmony.

Once upon a time a great motion-picture palace was opened; and an array of notable New Yorkers was invited to the first night. For at least ten minutes, but for what seemed the better part of an hour, the audience was treated to a succession of lighting effects, to the raising and lowering of the orchestra platform, and to the manifold ways in which the curtain could be lifted and parted. For a while, the audience was delighted by the technical virtuosity displayed: but when nothing further seemed about to happen, they were bored: they were waiting for the real performance to begin.

Modern architecture is now in a state similar to that of the Radio City Music Hall on the opening night. Our best architects are full of technical facility and calculated competence: but from the standpoint of the audience, they are still only going through the mechanical motions. The great audience is still waiting for the performance to begin. Now, in all systems of architecture, both function and expression have a place. Every building performs work, if it is only to keep off the rain or to remain upright against the wind. At the same time, even the simplest structure produces a visual impression upon those who use it or look at it: unconsciously or by design, it says something to the beholder and modifies, in some slight degree at least, his organic reactions. Functions that are permanently invisible remain outside the architectural picture; hence a building below ground may not be called architecture. But every function that is visible contributes in some degree to expression. In

simple monuments, like obelisks, or even in more com-
plex structures like temples, the function of the building
is subordinate to the human purpose it embodies: if such
structures do not delight the eye and inform the mind,
no technical audacity can save them from becoming
meaningless. Indeed, ideological obsolescence is more
fatal than technical obsolescence to a work of architec-
ture. As soon as a building becomes meaningless, it dis-
appears from view, even though it remain standing.

Modern architecture crystallized at the moment that
people realized that the older modes of symbolism no
longer spoke to modern man; and that, on the contrary,
the new functions brought in by the machine had some-
thing special to say to him. Unfortunately, in the act of
realizing these new truths, mechanical function has
tended to absorb expression, or in more fanatical minds,
to do away with the need for it. As a result, the architec-
tural imagination has, within the last twenty years, be-
come impoverished: so much so that the recent prize-
winning design for a great memorial, produced by one
of the most accomplished and able of the younger archi-
tects, was simply a gigantic parabolic arch. If technics
could not, by itself, tell the story of the pioneer, moving
through the gateway of the continent, the story could
not, in the architectural terms of our own day, be told.
This failure to do justice to the symbolic and expressive
functions of architecture perhaps reached its climax in
the design of the United Nations Headquarters, where
an office building has been treated as a monument, and
where one of the three great structures has been placed
so as to be lost to view by most of the approaches to the
site.

By now, many architects have become aware of a self-imposed poverty: in absorbing the lessons of the machine and in learning to master new forms of construction, they have, they begin to see, neglected the valid claims of the human personality. In properly rejecting antiquated symbols, they have also rejected human needs, interests, sentiments, values, that must be given full play in every complete structure. This does not mean, as some critics have hastily asserted, that functionalism is doomed: it means rather that the time has come to integrate objective functions with subjective functions: to balance off mechanical facilities with biological needs, social commitments, and personal values. And to understand the new prospects that open before architecture, we must first do justice to functionalism and to see how it came about in our time that the mechanical part was taken for the whole.

As so often happens, functionalism came into the world as a fact long before it was appraised as an idea. The fact was that for three centuries engineering had been making extraordinary advances in every department *except* building; and it was high time that the interest in new materials and technical processes, associated in particular with the fuller use of iron and glass, along with the mass production of standard units, should find its way into building. Functionalism resulted in the creation of machines, apparatus, utensils, structures, completely lacking in any expressive intention, but designed with utmost rigor for effective operation. Even before the machine exerted its special discipline, functionalism tended, in other departments of building, to produce strong geometric or organic forms. A barn or a haystack

or a silo, a castle, a bridge, a seaworthy sailing vessel—
all these are functional forms, with a certain cleanness of
line and rightness of shape that spring, like the shape of
a gull or a hawk, from the work to be performed. By and
large people do not stop to contemplate or enjoy such
structures until they have ceased to use them, or at least
until they pause to take in the meaning of what they
have done. But these buildings have at least the quality
of all organic creations: they identify themselves and so
symbolize the function they serve. When a steam loco-
motive is fully developed, for example, so that all its ex-
crescences and technological leftovers are absorbed in
a slick over-all design, "streamlined" as one now hesitates
to say, that locomotive not merely *is* more speedy than
the primitive form, but it says speed, too. All these de-
velopments had a special message for architecture; for
the expressive effects of architecture in all its great
periods had been due in large part to the absorption and
mastery of these engineering elements: pure building.

One of the first people to understand both the sym-
bolic implications and the practical application of func-
tionalism was an American sculptor, Horatio Greenough.
He published his thoughts, at the end of his all-too-brief
life, on his return to America, in a series of papers that
were first unearthed—they had been lying quietly on
library shelves—by Mr. Van Wyck Brooks and have
lately been republished. But since Greenough's mind
powerfully effected contemporaries like Emerson, it is
very likely that his contribution worked quietly under
the surface of American life, affecting later critics like
James Jackson Jarves and Montgomery Schuyler, even
when they were unaware of their sources or negligent in

acknowledging their debt. It was Greenough who carried further, as a student of anatomy as well as sculpture, the great theorem of Lamarck: Form follows function. This principle carries two corollaries: forms change when functions change, and new functions cannot be expressed by old forms. Greenough saw that this applied to all organic forms, even man-created ones. He recognized that the effective works of art in his own day, the primitives of a new era, were not the current specimens of eclectic decoration and eclectic architecture, but the strong virile forms, without any other historical attachment than to their own age, of the new tools and machines, forms that met the new needs of modern life. The American ax, the American clock, the clipper ship —in every line of these utilities and machines necessity or function played a determining part. They were without ornament or decorative device of any kind, except perhaps for a surviving ship's figurehead: like the naked body, when harmoniously developed, they needed no further ornament or costume to achieve beauty. For what was beauty? "The promise of function."

As expressed by Greenough, that was a breath-taking, a spine-tingling thought; and in the minds of Greenough's successors, such as the architect Louis Sullivan, who might well have breathed in Greenough's words with his native New England air, this doctrine provided a starting point for the new architecture. Until the twentieth century, however, the movement toward functionalism in architecture went on almost in spite of the architect, rather than through his eager efforts. The great new constructions of the nineteenth century were as often as not the work of engineers: the Crystal Palace of 1851,

the Brooklyn Bridge of 1883, the Paris Hall of Machines of 1889 were all works of engineering, though some vestigial remnants of early expressive elements remained even in structures as pure as Roebling's masterpiece, in his choice of a gothic arch in the stone piers, capped by the remains of a classic cornice.

But though all these new works tended toward a certain starkness, a certain severity and simplicity, that quality was not altogether the work of the new engineers, nor even the automatic result of the new industrial process. Economy and simplicity have their roots in the human spirit, too. The desire to slough off symbolic excrescences, to avoid ornateness of any sort, to reduce even speech to its simplest forms, and to remain quiet when one has nothing to say—behind all that is something else, a religious sense of life, to which those who have dealt with architecture have hardly yet done justice. But the fact is that the new functionalism in architecture owed something to a fresh religious impulse, that of the Society of Friends, those sincere Christian souls who sought to get back to the unadorned innocence of the primitive Christian Church. They rejected ornament of any kind either in dress or in speech, as offensive to an inner purity of spirit; their directness, their matter of factness, their underemphasis, their severity and probity, had an effect upon modern ways out of all proportion to their numbers. Democratic simplicity in dress and in manners passed over into architecture, only to disappear once more in our day as technological over-elaboration takes the place of more obvious forms of symbolic superfluity. On that miscarriage of the machine I shall presently have something further to say.

But while Greenough's doctrine was a salutary one, it was incomplete; for it partly failed to do justice to those human values that are derived, not from the object and the work, but from the subject and the quality of life the architect seeks to enhance. Even mechanical function itself rests on human values: the desire for order, for security, for power; but to presume that these values are, in every instance, all-prevailing ones, which do away with the need for any other qualities, is to limit the nature of man himself to just those functions that serve the machine.

Perhaps it would be profitable at this point to contrast Greenough's doctrine of functionalism with the conception of architecture that John Ruskin advanced in *The Seven Lamps of Architecture*. Contrary to popular misinterpretation, Ruskin had a very healthy respect for the functional and utilitarian triumphs of the Victorian age, and even his complaint against the barbarous effects of the new railroad trains, though petulant and often childish in tone, was only the voice of a good conservationist who understood that filth and dirtiness and land erosion and stream pollution were not evidences of industrial efficiency. But Ruskin insisted that building was one thing and architecture was another: a building became architecture, in his theory, when the structure was enhanced and embellished with original works of sculpture and painting.

This theory of architecture—which would make architecture dependent upon the symbolic contributions of the nonarchitectural arts—seems to me, in the form Ruskin gave it, a downright false one; and certainly it is impossible to reconcile with Greenough's conception

of functionalism. But it has the virtue of pointing to the expressive and symbolic aspects of architecture and underlining their importance. The basic truth in Ruskin's statement comes out just as soon as one replaces the restricted notion of painting and sculpture applied to an otherwise finished building, with the larger concept of the building as itself an expressive work of multi-mural painting and architectonic sculpture. By his choice of materials and textures and colors, by the contrasting play of light and shade, by the multiplication of planes, by the accentuation, when necessary, of sculpture or ornament, the architect does in fact turn his building into a special kind of picture: a multidimensional moving picture, whose character changes with the hours and seasons, with the functions and actions of spectators and inhabitants. Similarly, he creates in a building a unique work of sculpture, a form one not merely walks around but walks into, a form in which the very movement of the spectator through space is one of the conditions under which the solids and voids of architecture have a powerful esthetic effect, not known in any other art. The most daring innovations of the sculptor Henry Moore are in fact the esthetic commonplaces of architecture. And only when a building can be conceived and modeled so as to achieve a maximum degree of expression by the use of the material elements proper to building, only when the architect has sufficient means to play freely with the structure as a whole, modeling plan and elevation into a plastic unity, emphasizing its special meanings, intensifying its special values, does architecture in fact emerge from building and engineering. At that moment, Ruskin

and Greenough, symbolic beauty and functional beauty, are reconciled.

Now, no matter how rapidly our technical processes change, the need for expression remains a constant in every culture; without it the drama of life cannot go on, and the plot itself becomes pointless and empty. Life must have meaning, value, and purpose, or we die: we die standing on our feet, with our eyes open, but blind, our ears open but deaf, our lips moving but speechless. And we cannot, by any mechanical duplication of old symbols, come to a realization of the vital meanings in our own life. Our intercourse with other ages can only be of a spiritual nature. Everything we take over from the past must disappear in the act of digestion and assimilation, to be transformed into our own flesh and bones. Each age then must live its own life. But because of the need for finding meaning and value in our own works and days, our civilization can no more forgo symbolic architecture than could any earlier civilization.

So it came about that symbolic expression, driven out the front door by the doctrine that form follows function, came in by the rear entrance. The conscious theories of functionalists from Greenough to Sullivan, from Adolph Loos to Gropius, have by now succeeded in eliminating almost every historic or archaic mode of symbolism. They established the fact that a modern building cannot be imitation Egyptian, imitation Greek, imitation Medieval, imitation Renascence, or imitation hodgepodge. Their new structures were not refurbished traditional forms, improved with modern plumbing and elevator service; they were naked, clean, properly devoid of extraneous

ornament. *But still they said something.* They were not merely products of the machine; they revealed that the machine itself might become an object of veneration; and that an age that despised and debunked symbols might nevertheless, like the hero of a forgotten play by Eugene O'Neill, find itself worshiping a dynamo. Feelings and emotions that hitherto had attached themselves to organisms and persons, to political and religious concepts, were now being channeled into machine forms. These new forms not merely revealed function: they reveled in function, they celebrated it, they dramatized the mathematical and the impersonal aspects of the new environment. And so far forth the new buildings were symbolic structures.

My point here is that much of what was masked as strict functionalism during the last generation was in fact a sort of psychological if not religious fetichism: an attempt, if I may use Henry Adams's well-worn figure, to make the Dynamo instead of the Virgin serve as an object of love and devotion. Since both the true functionalist and the fetichist have used the same kind of technical means, it sometimes requires acute insight to distinguish one from the other at first glance; though with a little further acquaintance with the building itself one readily discovers whether it actually stands up well and works well, or whether it only is an esthetic simulacrum of structures that do such things. In short, those who devaluated the human personality, and in particular subordinated feeling and emotion to pure intellect, compensated for their error by overvaluing the machine. In a meaningless world of sensations and physical forces, the machine alone, for them, represented the purposes of life. Thus

the machine became a symbol to contemplate, rather than an instrument to use: it was (mistakenly) identified with the totality of modern life. That error was an easy one to fall into; for a large part of the modern world has been created, with the aid of mathematics and the physical sciences and mechanical invention; and no honest construction in our time can avoid in some measure expressing this discipline and acknowledging this immense debt.

Naturally, a certain unified method of approach, a certain common way of thinking, a certain common technical facility, must underlie the forms of our age. But to assume that the machine alone should dominate the forms of twentieth century architecture, symbolically as well as functionally, does not show any real insight into either the dangers of mechanization or into the pressing need of bringing other human motives and purposes back into the center of the picture. The machine, treated as a symbol, was used as a substitute for the whole. To assume that seaside houses should look like ocean steamships, as Le Corbusier did in his cruder moments, or to assume that a building should look like a cubist painting or constructivist abstraction, is not a functional assumption at all. As a symbol, the machine might properly have represented the partial, lopsided culture of early nineteenth-century industrialism. But we know in 1951 as men did not know in 1851, that the machine is only a limited expression of the human spirit: that this is not just the age of Faraday and Clerk-Maxwell and Einstein; it is also the age of Darwin and Marx and Kropotkin and Freud, of Bergson and Dewey and Schweitzer, of Patrick Geddes and A. J. Toynbee. In

short, ours is an age of deep psychological exploration and heightened social responsibility. Thanks to advances in biology, sociology, and psychology, we begin to understand the whole man; and it is high time for the architects to demonstrate that understanding in other terms than economy, efficiency, and abstract mechanical form.

In the multidimensional world of modern man, subjective interests and values, emotions and feelings, play as large a part as the objective environment: the nurture of life becomes more important than the multiplication of power and standardized goods, considered as ends in themselves. The Machine can no more adequately symbolize our culture than can a Greek Temple or a Renascence Palace. On the contrary, we know that our almost compulsive preoccupation with the rigid order of the machine is itself a symptom of weakness: of emotional insecurity, of repressed feelings, or of a general withdrawal from the demands of life. To persist in the religious cult of the machine, at this late day and date, is to betray an inability to interpret the challenges and dangers of our age. In this sense, Le Corbusier's polemical writings, beginning with his publication of *Towards a New Architecture,* were in no small measure a reactionary influence: retrospective rather than prophetic.

Now all this is not to say that the doctrine that form follows function was a misleading one. What was false and meretricious were the narrow applications that were made of this formula. Actually, functionalism is subject to two main modifications. The first is that we must not take function solely in a mechanical sense, as applying only to the physical functions of the building. Certainly new technical facilities and mechanical functions re-

quired new forms: but so, likewise, did new social purposes and new psychological insights. There are many elements in a building, besides its physical elements, that affect the health, comfort, and pleasure of the user. When the whole personality is taken into account, expression or symbolism becomes one of the dominant concerns of architecture; and the more complex the functions to be served, the more varied and subtle will the form be. In other words—and this is the second modification—expression itself is one of the primary functions of architecture.

On hygienic grounds, for example, the architect may calculate the number of cubic feet of space necessary to provide air for a thousand people in a public hall; and with the aid of the exact science of acoustics—plus a little luck—he may design a hall which will enable every person to hear with a maximum of clarity every sound that is made for the benefit of the audience. But after the architect has made all these calculations, he has still to weight them with other considerations that have to do with the effect of space and form on the human soul. In the cathedrals of the Middle Ages economy, comfort, and good acoustic properties were all cheerfully sacrificed to the magnification of glory and mystery, in a fashion designed to overwhelm the worshiper. In terms of medieval culture, that was both effective symbolism and true functionalism. In the strictly graded aristocratic society of the Renascence, in which music itself was subservient to the ostentatious parade of upper-class families, seeking to impress each other and the populace, the Palladian horseshoe form of opera house, with poor acoustic properties but excellent visibility for the box

holders, likewise did justice to the functions of the building in the order of their social importance, within that culture.

In other words, every building is conditioned by cultural and personal aims as well as physical and mechanical needs. An organic functionalism, accordingly, cannot stop short with a mechanical or a physiological solution. So in the rebuilding of the House of Commons, Mr. Winston Churchill wisely insisted that the seating space should be considerably smaller than the actual membership, in order to preserve the closeness and intimacy of debate in the House, under normal conditions of attendance. That decision was as wise as the medieval decoration that went with it was inept and meretricious; though an original modern architect might have found a means of echoing, in works of original sculpture, the traditional ceremonies and symbols so assiduously preserved in the British Parliament, beginning with that medieval relic, the Speaker's mace.

The architecture of Frank Lloyd Wright was subjected to a considerable amount of arbitrary critical disparagement during the 1920s when mechanization and depersonalization were regarded, with Le Corbusier, as the all-sufficient ingredients of contemporary form. But this disparagement was based on the very qualities that made Wright's architecture superior to the work of Le Corbusier's school. In Wright's work, the subjective and symbolic elements were as important as the mechanical requirements. From his earliest prairie houses onward, both the plan and the elevations of Wright's buildings were informed by human ideals, and by a sense of what is due to the person whose varied needs and interests

must be reflected in the building. It was the idea of the organic itself, the desire to embrace nature, that led to the introduction of the garden into the interior; it was the idea of horizontality as an expression of the prairie that led Wright to emphasize horizontal lines in his early regional houses. So, too, in Wright's later work, a geometrical figure, a circle or a hexagon or a spiral, the expression of a subjective human preference, supplies the ground pattern for the whole building. In such instances, as the late Matthew Nowicki pointed out, the old formula is reversed—function follows form: man dictates to nature.

Now, when subjective expression is overplayed the results are not always happy—any more than was the case in Renascence buildings, where the idea of axial balance and symmetry determined both plan and elevation. But to say this is only to admit that, if mechanical functions, taken alone, do not fulfill all human needs, so subjective expressions, if divorced from practical considerations, may become willful, capricious, defiant of common sense. Accordingly, the more sensitive the architect is to expression, the more capable he is of transforming "building" into "architecture," the greater the need for his own self-knowledge, self-control, self-discipline: above all, for subordinating his own inner willfulness to the character and purposes of his client.

On this latter score, Frank Lloyd Wright's work is sometimes not impeccable; for all too rarely has he been faced with a client sufficiently strong in his own right to stand up to Wright's overbearing genius, in a way that will do justice to every dimension of the problem. But one thing is usually in evidence in Wright's architec-

ture—not the machine but the human person has taken command. Hence Frank Lloyd Wright's wealth of designs is marked, not by any mechanical uniformity, but by an endless diversity and variety, held together by the underlying unity of Wright's own very positive personality; and whatever criticisms one may make of his buildings in detail—and I have made sundry criticisms in my time—one finds that as a whole they stand preeminent among the structures of our time precisely because they unite the mechanical and the personal. Here form follows function and function follows form, in a rhythmic interplay between necessity and freedom, between construction and choice, between the object-determined self and the self-determined object. In Wright's fertile and inventive use of the machine, combined with a refusal to be cowed by it or intimidated by it into a servile disregard of his own purposes, his work has been prophetic of a future in which art and technics will be effectively united.

How hard it is to achieve such structures, at once functional in all their offices and arrangements and duly symbolic of their own human purposes, we can see when we examine a building near at hand: the new Secretariat Building of the United Nations. That great oblong prism of steel and aluminum and glass, less a building than a gigantic mirror in which the urban landscape of Manhattan is reflected, is in one sense one of the most perfect achievements of modern technics: as fragile as a spider web, as crystalline as a sheet of ice, as geometrical as a beehive. On this structure almost a score of the best architectural and engineering minds of our day were at one time or another at work. But unfortunately, the

genius presiding over this design was an architectural doctrine altogether too narrow and superficial to solve the actual problem itself. The very decision to make the Secretariat building the dominant structure in this complex of buildings reveals at the start either a complete indifference to symbolism, or a very wry reading of the nature and destiny of the United Nations. With relation to the city itself, a forty-two story building cannot possibly express dominance: it is just another skyscraper in an urban heap of skyscrapers, actually seeming even lower to the eye than it is in fact, because the river front where it stands drops sharply below the escarpment above it. With relation to the General Assembly Building, the overwhelming dominance of the Secretariat is ridiculous—unless the architects conceived it as a cynical way of expressing the fact that Burnham's managerial revolution had taken place and that the real decisions are made in the Secretariat, by the bureaucracy.

Has this building then been conceived with a strict regard to its functions as an office building? Did the architects seize the opportunity to create, for the example of the rest of the world, an ideal office building, freed as they were from the constraints of realty speculation, constricted building lots, and metropolitan overcrowding? Unfortunately, as a functional unit, the Secretariat Building is even more lacking in merit, if this is possible, than as a symbol. This structure, as the chief architect has explained, is really three separate office buildings, each with its own elevator and ventilating machinery, piled one on top of the other. In other words, there is no functional reason whatever for its present height. For the purely esthetic purpose of creating an unbroken glass

surface for the façade, as much money must be spent on washing the spandrels between the windows as for washing the windows themselves; and that high cost of upkeep, added to the excessive cost of artificial ventilation, takes away income sorely needed for other purposes. But this is not all. In order to create the purely abstract esthetic effect of an unbroken marble slab on the north and south ends of the building—and in order incidentally to give a large expanse of window space to the women's lavatories, for reasons no one can explain—about a quarter of the perimeter of the building, which might have been used to give natural lighting to the offices, has been sacrificed. And what is the functional result? The result is that a large number of secretaries, instead of working under ideal conditions, as they should in such a building, work in dreary interior cubicles that lack sunlight and air and view: advantages they might have enjoyed if functional considerations had been sufficiently respected. Surely that was a disreputable blunder to make in providing working quarters for an organization that is attempting, on a world-wide scale, to improve the conditions of the worker. In such a building bad working conditions mean bad symbolism.

In short, the sound functional requirements of the Secretariat Building were sacrificed so as to give esthetic purity to a symbol that is not a symbol, unless we accept this skyscraper as an eloquent but unintentional symbol of the general perversion of life values that takes place in a disintegrating civilization. The Secretariat Building —or, rather, the complex of modest buildings that might have formed the Secretariat—should have been treated neither as a monument nor a symbol, still less as an imita-

tion of a commercial New York skyscraper. The Secretariat should have been planned on the human scale, subordinated in its placement and design to the Assembly Building. The office buildings should have been designed with something more than lip service to economy, to mechanical function, above all, to the actual working needs of their occupants. Instead of having their substance wasted on elaborate mechanical utilities, introduced to counteract the massive errors in general design, the buildings should have been correctly oriented for sun and wind, and surrounded by trees and lawns that would have provided a pleasant microclimate both for winter and summer, with due architectural provision for intervals of recreation and social intercourse that are denied the inmates of the present building. By departing from the meretricious errors of New York speculative building—the pattern and model of the present structure—the architects of the Secretariat might have established a model for all future office buildings, in whose design human considerations would predominate above profit or prestige or mechanical fetichism.*

Conceived in this fashion, the very functions of the Secretariat would have produced the correct symbol, one duly subordinated to the main effort to hold the eye and elevate the spirit through the development of the Assembly Building and the design and gardening of the site as a whole. Instead, the designers of the Secretariat Building sacrificed both mechanical efficiency and human values in order to achieve an empty abstract form, a frozen geometrical concept, that reflects the emptiness

* For a more detailed analysis, see "The Sky Line," *The New Yorker,* September 15 and September 22, 1951.

and purposelessness of modern technics, as now conceived. Certainly it expresses nothing about the purposes and values of a world organization, dedicated to peace and justice and the improvement of human life. In short, the Secretariat Building exhibits both a breakdown of functionalism and a symbolic black-out. Though mechanically new, it is architecturally and humanly obsolete. That is almost a definition of the pseudo-modern.

The architect who perhaps came closest among our contemporaries to resolving function and expression was the late Matthew Nowicki, he whose early death in an airplane accident in 1950 was a loss comparable to that architecture sustained when John Wellborn Root died at an equally early age. In the course of some forty intense years of life, Nowicki had passed through the various phases of modern architecture represented by cubism, by mechanical functionalism and *Sachlichkeit*, by Le Corbusier's "International Style." Firmly rooted in our own age, he regarded the standard unit, the module, as an essential discipline for the modern architect: the minimum ingredient for form. In such designs as that for the great amphitheater in the State Fair Grounds at Raleigh, North Carolina, now under construction, he used that typical modern form, the parabolic arch, to enclose the facing ranks of the grandstand: an acrobatic feat of great audacity and beauty, appropriate to the functions it served.

But Nowicki knew that all buildings speak a language, and that this language must be understood by the people who use it. When he worked on the preliminary designs for the library and the museum that were to be erected near the State House in Raleigh, he took into account the

love and affection the people of North Carolina feel toward that fine piece of provincial classicism. For the sake of meeting their sentiment half way, he was ready to utilize artificial lighting throughout the new buildings in order to create a solid masonry structure which, in its own modern way, would carry on the theme of the beloved older building. That tact, that understanding, that human sympathy stand in full contrast to Le Corbusier's constant demand for people cut to the measure of his own architecture: like old Procrustes, he would amputate the human leg or stretch the human soul to fit the form he has arbitrarily provided for it.

So, again, when Matthew Nowicki went to India to work on the design of a new capital for the East Punjab (with Mayer and Whittlesey), he brought with him no ready-made stereotypes from the West, but absorbed, with his marvelous sensitivity and intuitive grasp, the Hindu way of life, sympathetic even to the fathomless richness and complexity that expressed itself traditionally in ornament. In the intimate plans for housing and neighborhood units, above all in one of the sketches for the Capitol itself, Nowicki translated this richness into patterns and plans that were wholly in the vernacular of modern building, yet were native to the scene and in resonance with the Hindu personality and with Hindu family life.

Rigorous in its physical foundations, Nowicki's architecture rose above them to the plane of the social and the personal. Through his humility and human sympathy, through his reverence for all genuine expressions of life, he was equipped as no other architect of his generation perhaps was to effect a fuller reconciliation of the organic

and the mechanical, the regional and the universal, the abstract-rational and the personal. Along the path that he began to blaze, modern architecture, if it is to develop and grow, must follow, creating forms that will do justice to every aspect of the human organism, body and spirit in their living unity.

The problem of form, as I have put it to you in these examples, is plainly one that cannot be solved, even in engineering, to say nothing of architecture, merely by a systematic application of science, or by treating the machine as a religious fetich. The problem of form is not one of esthetics alone, either, though esthetics brings us into one of the inner chambers of the human personality, for a work of organic architecture must take in social and moral needs. When we talk of an organic architecture we refer to a system of order capable of bringing all these requirements into an harmonious and effective relationship. We are looking for a rule, as Louis Sullivan's French mathematics teacher put it, a rule so broad as to admit no exceptions.

Along such lines art and technics, the symbol and the function, are now in process of being reconciled in the best works of modern architecture; and to the extent that this is actually taking place there is reason to hope that our civilization, which shows so many signs of disruption, may in fact be able to halt its insane expansion of power without purpose, and find ways of bringing into effective unity the now hostile and divisive tendencies of men. But this is no easy road; and such backward-looking buildings as the UN Secretariat Building—of all buildings in all places!—are a proof of that fact. Hence in my final lecture, I purpose to examine the more general

terms for establishing unity, not merely between art and technics, but between all the divided sides of modern man's life. For unless the will to achieve integration is a universal one, neither art nor technics will long prosper.

Art, Technics, and Cultural Integration

WHEN I BEGAN these lectures I announced that my underlying purpose was to use the development of art and technics as a means of throwing some light upon the major problems of our all too "interesting" age; particularly the problem of cultural and personal integration. My basic assumption is that our life has increasingly split up into unrelated compartments, whose only form of order and interrelationship comes through fitting into the automatic organizations and mechanisms that in fact govern our daily existence. We have lost the essential capacity of self-governing persons—the freedom to make decisions, to say Yes or No in terms of our own purposes —so that, though we have vastly augmented our powers, through the high development of technics, we have not developed the capacity to control those powers in any

proportionate degree. As a result, our very remedies are only further symptoms of the disease itself.

Our technics has become compulsive and tyrannical, since it is not treated as a subordinate instrument of life; while, at the same time, our art has become either increasingly empty of content or downright irrational, in an effort to claim a sanctuary for the spirit free from the oppressive claims of our daily life. The images of the abstract painters do justice to the blankness and disorganization of our lives; the images of the surrealists reflect the actual nightmare of human existence in an age of mass exterminations and atomic catastrophes. If they are not so pure forms of art as their admirers usually believe, they at least tell us more about the current state of the world than the newspapers or radio. Such paintings are of value as documents, even if they are sometimes almost worthless as art. Those who could interpret these images during the last twenty years had a far better grasp of the shape of things to come than those puerile politicians who prided themselves on their common sense and their realism; and who were therefore ready for neither the sacrifices of war nor the even greater disciplines and renunciations now needed to achieve peace.

Underneath my discussion of the symbol and the tool, of the development of the machine arts and the dangers of the reproductive process when uncontrolled, likewise underneath my discussion of the symbol and function in architecture, was an effort to arrive at some understanding of a crucial question for our time: Why has our inner life become so impoverished and empty, and why has our outer life become so exorbitant, and in its subjective satisfactions even more empty? Why have we become

technological gods and moral devils, scientific supermen and esthetic idiots—idiots, that is, primarily in the Greek sense of being wholly private persons, incapable of communicating with each other or understanding each other? I put these questions in the most extreme form possible, for the sake of clarity, trusting that you will supply the shadings that would turn these diagrammatic contrasts into workable truths, giving due weight to all the symptoms of health, integrity, vitality, creativeness that are still visible in our society.

The conditions I have been trying to fathom in our own time are, you must note, just the reverse of the conditions in which art and technics originally took form in human society. For in the beginning, men worshiped the symbol as a magical power; whether as word or as image it was the very core of their humanness, the condition for their emergence beyond a purely instinctual animal intelligence. For a long period, the symbol made men arrogant, and they undervalued the tool and the process it furthered. But today just the opposite condition prevails. We are full of humble misgivings or withering cynicism about the symbol. Thanks to the gorging abundance of our reproductive devices, we deface the symbol and debase it, treating it contemptuously, negligently, only half-believing that its employment makes any difference. By contrast, we overvalue the technical instrument: the machine has become our main source of magic, and it has given us a false sense of possessing godlike powers. An age that has devaluated all its symbols has turned the machine itself into a universal symbol: a god to be worshiped. Under these conditions, neither art nor technics is in a healthy state.

Art, as I have sought to define it in these lectures, is only one of the ways in which man re-orders, reflects upon, and re-presents his experiences to himself, attempting to arrest life in its perpetual flux and movement, so that human experience can detach itself, in the esthetic object, in its final perfection and fulfillment. And what does art say, in all its manifestations, from a child's song to a symphony, from a scratch on a cave wall to a great complex mural like the Orozco mural at Dartmouth College? In the work of art the artist, first of all, says: "I am here and in me life has taken a certain form. My life must not pass till I master its meaning and value. What I have seen and felt and thought and imagined seems to me important: so important that I will try to convey it to you through a common language of symbols and forms, with something of the concentration, some of the intensity, some of the passionate delight that I carry to the highest pitch in myself through the very act of expression. With the aid of art I give you, in the present, the experience of a lifetime: the potentialities of many lifetimes. These esthetic moments endow life with a new meaning; and these new meanings heighten life with other esthetic moments."

So says the artist. And though the symbols that are used in any culture must, to be understood and experienced, have some common ground, each fresh work of art is unique, because it is the representation, not of other artists' symbols—only mediocre and imitative art is that—but of the unique experience of a creative moment in life. With the expression of a true work of art the goodness of life is affirmed, and life itself renewed. The work of art springs out of the artist's original ex-

perience, becomes a new experience, both for him and the participator, and then further by its independent existence enriches the consciousness of the whole community. In the arts, man builds a shell that outlasts the creature that originally inhabited it, encouraging other men to similar responses and similar acts of creativity; so that, in time every part of the world bears some imprint of the human personality. Art, so defined, has no quarrels with either science or technics, for they, too, as Shelley long ago recognized, may become a source of human feelings, human values. The opposite of art is insensibility, depersonalization, failure of creativity, empty repetition, vacuous routine, a life that is mute, unexpressed, formless, disorderly, unrealized, meaningless.

All that art is and does rests upon the fact that when man is in a healthy state, he takes life seriously, as something sacred and potentially significant; and he necessarily takes himself seriously, too, as a transmitter of life and as a creator, through his own special efforts, of new forms of life not given in the natural world. With his capacity for symbolization, man re-thinks, re-presents, re-patterns, re-shapes every part of the world, transforming his physical environment, his biological functions, his social capacities into a cultural ritual and drama full of unexpected meanings and climactic fulfillments. What exists outside man, as raw nature, the artist takes into himself and transmutes: what exists in himself, as sensation, feeling, emotion, intuition, insight, rationality, he projects outside himself in forms and sequences not given in nature; so that the growth of human culture is not simply marked, as Mr. Arnold

Toynbee supposes, by the transfer of interest and power from the external world to the interior, with an increasing "etherealization" of the material conditions of life: it is likewise marked by a transfer of man's innerness to the outer world, with a corresponding materialization of man's subjective powers, a corresponding outward manifestation of his inner creativity.

Man truly lives only to the extent that he transforms and creates out of the raw materials of life a world whose meanings and values outlast his original experience and transcend its limitations. That is, essentially, one of the great tasks of art; though art is not alone in performing that function, since it feeds and grows on man's other modes of self-explication and cosmic insight. For art to perform this function, however, at least one condition is necessary: man must respect his own creativity. As soon as man loses faith in his own potential significance and value, he reduces himself to the status of an animal who has lost the sureness of his elemental instinctual responses and must therefore take refuge in some even simpler mechanical pattern of order.

Does this not explain why the failure of art in our own time and the overvaluation of the machine have gone hand in hand; and why both of these facts have been symptoms of a more general social and personal disruption?

Now, the disintegration of modern Western culture, so well exemplified in the present breach between our superrefined technics and our primitive or infantile esthetic symbols, between our overactive technical organization and our empty, discredited selves, can be interpreted in more than one way. At the end of the

First World War, a German philosopher of history, Oswald Spengler, attempted a universal explanation of the facts that we are now confronting, in a book that prophesied, not without a certain sadistic elation, the downfall of the Western World. Spengler divided the development of every culture into two phases: first, a humane organic phase, the springtime of culture, when man's powers ripen and the arts flourish as a natural expression of his inner life and creativity; and, second, an arid mechanical phase, with life on the downward curve, a phase in which men become extraverted and externalized, given to organization and to the creation of hardened forms of life, creating a shell of empty custom and habit that prevents any further growth, so that, if the civilization that so takes form continues for any length of time, it is given over merely to vain repetitions, with no fresh content or meaning. In our own particular culture, Spengler believed, this tendency to subjective emptiness and external fixity was abetted by Western man's mastery of mechanical inventions; and in the final phase, now upon us according to his formula, those who understood their fate would give up lyric poetry in favor of business enterprise, painting and music in favor of engineering. This suicide of the inner man was but the prelude of a more general devaluation of life and a more widespread movement toward nihilism and self-extinction.

Probably only a few people read Spengler today; but perhaps that is because the times have already caught up with him. Spengler's prophecy, that an age of Caesarism was at hand, the most shocking part of his book in 1920, turned out to be far truer than most of his more rational

contemporaries, including myself, were willing at the time to grant; though in this respect Spengler was but mouthing with his usual excess of bad manners an observation that the great Swiss philosopher of history, Jacob Burckhardt, had made almost two generations before, in his *Weltgeschichtliche Betrachtungen*—now translated as *Force and Freedom*. On the other hand, Spengler's notion, that the days of art were over and that the time for technics, divorced from all other human values, had come, struck a note that found many echoes in contemporary life and thought. It brought, indeed, a certain comfort and consolation to those who were pushing through the processes of increasing mechanization, centralization, and depersonalization, by means of the advertising agency and the sales office, the military machine, the radio chain, and the gigantic assembly-line production unit. Those who were quantifying life in the interest of power, prestige, and profit found here a sanction for following the obvious path of least resistance. Complacent inertia could take the place of creativity. Unfortunately, as a result of this inertia, life itself was being hampered and curbed in that very expansion. The meanings of life were becoming more hollow, and even its new mechanical efficiency more superfluous and irrelevant, since out of all this abundance of power were coming only world-wide depressions, world-wide wars, world-wide acts of genocide, world-wide catastrophes. So that the final stage predicted by Spengler, of complete mechanization and brutalization, was only one step away from an equally universal empire of death. In that mood, the contemporary world has been perfecting its skyrocketing

automatons and its atomic and hydrogen bombs, while flinching from the social and personal initiatives that would produce a cooperative world order, a responsible world government—the essential conditions for peace. And so far Spengler, in his blackest moments of prophecy, seems right; though the best prophecy of all was that made long before Spengler by Henry Adams in a statement each of us should know by heart. *"At the present rate of progression since 1600,"* Adams wrote to Henry Osborn Taylor, *"it will not need another century or half century to tip thought upside down. Law in that case would disappear as theory or* a priori *principle and give place to force. Morality would become police. Explosives would reach cosmic violence. Disintegration would overcome integration."* The date of that prophecy gives it additional significance: the year was 1905.

That forecast now trembles on the brink of fulfillment: a cataclysmic fulfillment. But I shall not linger over that last statement, since the purpose of the lectures is to explore and understand the possibilities for a renewal of culture and personality. I will emphasize, rather, the defects in Spengler's general interpretation of human cultural development, however accurate his intuitions were in some respects as to the immediate forces that have been at work in our own day. The fact is that his division between culture and civilization, between the organic and the mechanical, between (in our immediate terms of reference) art and technics, transfers to the beginning and the end of the cultural cycle processes that are in fact constantly in operation at every stage. Only a very misty, sentimental eye would fail to see in the lush overgrowth of Medieval and

Renascence fortifications, for example, or the over-development of medieval armor, the same overweighting of technical facilities at the expense of life that the overdevelopment of subways and multiple express highways and atom bombs does in our civilization to-day. Only a very obstinate dogmatist would fail to see in the behavior of the mass of Londoners under bombing—not what Spengler predicted—the bloodless cowardice and pacifism of the life-renouncing denizen of megalopolis—but the same heroic qualities of selfless courage we associate with the springtime of chivalry. And if this is true even in war and engineering, it is equally true in a hundred other departments of life. The fact is that the organic and creative, the mechanical and automatic, are present in every manifestation of life, above all within the human organism itself. If we tend to exaggerate one phase and neglect the other, it is not because civilization inexorably develops in this fashion, but because, through a philosophic foundation of mainly false beliefs, we have allowed our balance to be upset, and have not actively regained that dynamic equilibrium in which state alone the higher functions—those that promote art, morality, freedom—can flourish. This failure of balance can take place at any stage of develop-ment; and sometimes, as I have pointed out, it is the overdevelopment of the inner life, the overproliferation of symbols, the excessive claims of subjectivity that are responsible for the mischief. In our time, however, we suffer chiefly because of the result of the unlimited license we have given to the machine.

Those who took Spengler's thesis seriously—and many who never heard of it accepted it in practice—

were in effect preparing to commit suicide; for they were transferring meaning and value to only one part of the environment, to only one process and function, to only one aspect of the human personality. That part, no matter how vastly one magnifies it or energizes it, can never become an adequate substitute for the whole. If technical achievements were alone capable of absorbing human interest and manifesting creativity, if the machine were in fact the only reputable source of value for modern man, that would mean that his biological and social and personal activities would all shrink and shrivel. They would be otiose and purposeless in such a world and even when they persisted, as of course they must persist in some form, they would themselves become subject to a similar kind of specialization and segregation which would, in the end, be their death.

We see something of this sort happening during the last generation among the painters. To begin with, a disturbing absence of the symbols of life and an equally disturbing multiplication of images of disorganization and destruction—ruined buildings, blasted landscapes, deformed figures, like Max Ernst's women with beards or dust brushes instead of faces, corpselike figures dissected by esthetic Bluebeards. One must not blame the painter for bringing forth these symbols. Just because of his acute sensitiveness to the emotional currents of his period, he would need spiritual powers of the greatest magnitude—or a capacity for retreating into himself and encapsulating himself—in order to produce anything different. Let me reinforce this point by an historic example. Certainly two of the healthiest painters who ever lived were Peter Brueghel the Elder and Francisco José

de Goya: strong, healthy, well-balanced spirits. But they both lived in an age of disintegration; and because they were honest enough to face every part of their experience, they both produced surrealist pictures of the most macabre kind, recording the horrors of war, the starvation and misery and torture they had witnessed and, what is more, had agonized over. Fortunately for themselves, fortunately for their contemporaries, fortunately for us, they knew Heaven as well as Hell: the delights of erotic love, of parenthood, of honest labor in tune with nature, the joy of the hunter and the plowman and the harvest hand. So, though they sensitively recorded the degradations of the day, they were still capable in their art of testifying to a fuller and better life.

Our period, unhappily, has not yet produced many Brueghels or Goyas in painting. The healthy art of our time is either the mediocre production of people too fatuous or complacent to be aware of what has been happening to the world—or it is the work of spiritual recluses, almost as withdrawn as the traditional Hindu or Christian hermits, artists who bathe tranquilly in the quiet springs of traditional life, but who avoid the strong, turbid currents of contemporary existence, which might knock them down or carry them away. These artists no doubt gain in purity and intensity by that seclusion; but by the same token, they lose something in strength and general breadth of appeal. Marsden Hartley in the older generation, or Morris Graves in our own day would be examples of this self-contained art: an art filled, indeed, with symbols of life, quivering with sensitiveness in the case of Graves, or knit together by an inner composure,

with Hartley, symbols that point to deeply felt and deeply meditated experiences of tenderness, passion, and love—all precious qualities in a grim and calloused age. The fact that such artists live and quietly sustain themselves is in itself a good sign, though it reveals nothing about our further social development, since this kind of artist has always found a cranny to grow in under the most unfavorable personal or social conditions.

What these self-enclosed artists reveal is the unshakeable determination of life itself to realize itself, as I think it was Amiel who said, "even under conditions of maximum opposition by external forces." But there are other signs of the replenishment of the spirit and of renewal in the arts, signs of a more positive nature. During the last generation, the arts have taken hold of a larger province in our schools, at least up to high school, a development that was undoubtedly helped indirectly by the general encouragement given to art during the 1930s by the Works Projects Authority. For all the inroads of mechanization, thousands of youngsters are now capable of modeling and painting, of acting and singing and playing in an orchestra, with both a creative exuberance and a technical skill their predecessors never had a chance to develop. Though the results of all this are perhaps more conspicuous in music than in the graphic and plastic arts, they are beginning to manifest themselves everywhere.

Perhaps the chief handicap to further creation here is that modern art has itself now become the accepted academic form; that the fashion of idealizing mechanical order, or of symbolizing disintegration and schizophrenic frustration, has itself become almost a hallmark

of sophisticated taste. In our time the painter who shows
a degree of robust health, comparable to Rubens or
Renoir, can hardly avoid being dismissed as mediocrity;
but that means, I suspect, that our symbols lag a little
beyond the new realities they should be opening up to
us. If you watch the way the young fall in love, get
married, and promptly, within the allotted nine months,
produce children—though subject to the possibility of
bitter partings and long absences, not to mention the
threat of more grisly catastrophes—you may conclude
with me that the latent vitality of our society is not as
yet adequately represented in our art. For the great
drama of life today, the most poignant source of ex-
pression is the effort to overcome disunity and disin-
tegration: to regain the initiative for life. Not by
seclusion but by immersion; not by retreating, but by
conquering the forces that threaten life.

Our failure so far to regain the initiative for the human
spirit, our inability, in general, to produce symbols that
would help restore our inner composure and confirm our
hidden desires and give buoyancy to sunken hopes, our
inability to pull ourselves out of a Bunyan-like Slough
of Despond in which we are struggling—all these
failures are not peculiar to the arts: they afflict in similar
ways almost every other activity. In a world whose need
for peace and brotherhood and planetary cooperation is
now close to absolute—since a false move here may
bring about a swift downfall of civilization—most of our
deliberate collective actions on both sides of the Iron
Curtain are in the direction of isolation, non-com-
munication, and destruction. We have submitted even
in democratic countries to an unconditional surrender of

the higher aspects of human life, justice, art, love, truth, fellow feeling, and have elevated into a position of command all the lower aspects of group existence— tribalism, irrational hatred, brutality, pathological self-assertion and self-adoration—all piously masked as a patriotic obligation. The automaton and the id, the uncontrolled machine and the unconditioned brute, have captured the normal sphere of the personality. In a desperate effort at compensation we bestow the attributes of personality upon a single dictatorial figure: the modern equivalent of the Saviour Emperor who first appeared in the third century B.C. in Greece, a time of similar disintegration. The Leader alone then becomes a real person. He alone is free to make decisions; he alone may obey his innermost impulses; he alone may shake off the crowd and defy regulations and routine; he alone may speak freely, without censorship, as one having authority. Vicariously, the cheated masses bestow upon the leader the feelings and the emotions, the capacity for taking the initiative, that they have allowed to be drained out of their own purposeless lives. Is that not the true psychological significance of the almost supernatural power wielded by a Mussolini, a Hitler, a Stalin: a power that has come forth once again, in our cynical, deflated, machine-conditioned country, in the person of a military hero of quite ordinary human dimensions, whom his more convulsed worshipers have proclaimed as nothing less than a god? In this vicarious acknowledgment of the role of personality, one has both the fulfillment and the denial of the primacy of the person; for in order to exercise such power a single individual must have, behind his solitary Number One,

a long train of zeros. The very existence of these irra-
tional reassertions of the person must only increase the
intensity and persistence of our present search to un-
cover more normal channels for exercising these
attributes.

Certainly, the present state of our civilization is not
a self-perpetuating one. If modern man does not recover
his wholeness and balance, if he does not regain his
creativity and his freedom, he will be unable to contain
the destructive forces that are now conspiring, almost
automatically, to destroy him; and even if they were
held in check, he will, if he continues along the present
route, in the end go completely out of his mind. It will
require only a little further commitment to machines
already in existence, a little further devaluation of the
person, a little more contempt for life and the values of
life, before modern man out of his boredom and purpose-
lessness, if not out of destructive malice, will let loose
his weapons of total extermination. He may do this,
though everyone knows, as General Douglas MacArthur
observed in 1945 and has lately said again, that there
can be no victory for either side in a third World War.
No victory and no peace. If our present state of un-
balance continues, with "art degraded and imagination
denied," our present society, for all its powers of organi-
zation, will bring on its own downfall. Given a little more
time, even a war would not be necessary to effect this
negation of life. A congealed condition of enmity, a
"deep-freeze war" prolonged for a generation, would be
sufficient to produce the same result. And what, then,
would become of our triumphs in technics?

Once life becomes entirely valueless, once good and

bad have ceased in our minds to exist, along with art and
its happy symbols of life—when this happens why
should anyone exert himself to achieve technical pro-
ficiency, as if power however immense could be of value
in a valueless world? Already the fatal words that would
bring the businessman and the engineer and the soldier
down in the same dust heap as the artist and the poet
have been spoken. From the gutters rises a cynical
question: *So what?* Unless you believe that life tran-
scends all its instruments and mechanisms, there is no
answer to that question. Irrationality, criminality, uni-
versal nihilism, suicide—along that road we shall march
until our inner powers flourish again sufficiently to com-
mand the machine we have created. To avert a tragic
end, the human person must come back onto the center
of the stage: not as chorus or spectator, but as actor and
hero, indeed as dramatist and demi-urge, summoning
the forces of life to take part in a new drama.

So we come to our final question. Is there then no
humane and life-giving alternative to the present
process of helpless mechanization and purposeless
materialism? Yes; I believe that there is a viable alter-
native, which is embedded in the very nature of man, for
his nature has many other capacities besides the gift
for exploiting scientific curiosity, for performing regular
work, and for fabricating machines. Furthermore, I be-
lieve that at a critical point we shall make a series of
new choices, just as deliberate as those which made the
machine itself a dominating factor in our lives; and that
if we make these choices in time to ward off disaster we
shall bring about a general renewal of life. Collective
changes of this nature are not the sudden result of some

dictatorial fiat: they are the cumulative outcome of many little day-to-day decisions, arising out of a new method of approach, a new set of values, a new philosophy. In the end they converge on a new plan of life which a multitude of people have already partly outlined and confirmed by practical experiment; and already we can see that many of these choices and commitments are being made. Once more the human person is coming back into the center of the picture.

Nowhere is this change more conspicuous than in modern industry. In this domain, though the multiplication of new inventions and technical devices has exceeded our powers of rational assimilation, there has been, at the same time, a shift of interest from the mechanical process to the human operator, in every department where automatism has not completely taken over. Psychological experiment and practical experience have both established the fact—first eloquently demonstrated by Professor Elton Mayo's Hawthorne experiments, now famous—that even mechanical efficiency is not solely a matter of engineering: it can be increased or decreased by purely emotional tensions and expressions. High mechanical efficiency per man hour, when it results in antagonisms that increase the incidence of illness and accidents, or bring on strikes, may produce a low efficiency per working year, when all the breaks and stoppages are reckoned in. And whereas the science and technics that arose in the seventeenth century had as the very secret of their method the displacement of man, the reduction of the person to a mechanical part, the science and technics of the future will increasingly use methods of simultaneous thinking, of multidimensional

integration, which will again bring back the whole man.

Not the least remarkable change that has taken place within industry during the past generation is a keen attention to the esthetic qualities of its products, along with a special attention to the order and comeliness of the industrial environment, so that the architecture of the motor works or the airplane factory or the industrial research laboratory has usually represented a higher standard of architectural achievement than most of our middle-class housing. The motive behind this concern with form is usually the very narrow one—sometimes downright meretricious—of sales appeal: it is perhaps not an accident that one of the greatest patrons of modern art has been the Container Corporation; nor is it an accident that most of the futile work that has been done in industrial design has been for the sake, not of improving the functional organization of a motor car or a typewriter, but of wrapping the finished product up in a neater, or more often a merely gaudier and more striking package. Still the impulse, whether it has a base objective or a sound one, actually allows for qualities and human interests that were flatly disregarded under a purely quantitative ideology of the machine. As Emerson said when pianos were imported by Western mining towns, "the more piano, the less wolf." So one may say of this new attention to the form and esthetic appeal of machine products, the more art can be integrated with the machine, the less need of art as a mere compensation. This is part of a more general humanizing influence that is beginning, even in the most mechanized spheres, to bring back a personal, I-and-Thou relationship, as Martin Buber would call it, into

realms hitherto mechanical, impersonal, not to say brutal.

All this means that a Confucian, if not Christian, human-heartedness is coming back into even the most routinized factory or office; and men, instead of feeling excluded and belittled by the machine's achievements, will increasingly feel released by them; so that all our mechanical operations, instead of being geared to produce the maximum quantity compatible with profit, will be geared to produce the maximum quantity compatible with a fully developed life for both the person and community. In such an order, we shall be able to curtail and simplify the products of the machine, not merely to elaborate, to expand, to multiply them. If necessary, we will dismantle our assembly lines in order to reassemble the human beings who have been harnessed to them. Our machines will doubtless become more exquisitely functional and efficient; but by the same token, they must occupy a smaller part in our actual life, just because of this further advance. The opportunities for qualitative choice and quantitative control will widen.

Do not conclude from these observations that I am here advocating the passage of a law for the abolition of machines, or that I am suggesting a thirty-year moratorium, say, on research in the physical sciences. If past experience indicates anything, such measures in a country like America would only lead to ingenious bootlegging and racketeering that would add to the formidable power exercised by the criminal elements who already uncomfortably control far too large a fraction of our life. What I am suggesting is quite another

possibility, a far more effective one, something that, if it were pushed too far, would even be capable of destroying our mechanical apparatus and our scientific laboratories with more utter devastation and irreparable loss than any number of atom bombs. That change is nothing less than a change of interest in the direction of the whole organism and the whole personality. A shift of values; a new philosophic framework; a fresh habit of life. Such a change has often happened before in history —most notably in the case of Rome, when the classic world fell under the sway of the Christian way of life. As you will recall, when that change took place, people ceased to build the mighty works of engineering that had made old Rome famous, the viaducts and aqueducts and sewers and concrete surfaced roads; they built churches and monasteries. They ceased to devote themselves to empirical knowledge; they turned to theology and mysticism. They ceased to be profiteers and extortioners, gambling with men's daily necessities; they bought and sold at a just price. On this new basis, they built a great civilization and enacted a great collective drama that came to its own climax in the thirteenth century.

Do you think perhaps that all this cannot happen again? That is a quaint belief for an age that believes that change alone is absolute, for why should people who hold this view believe that their own scheme of life, built so exclusively around the machine, is immune from the processes its philosophy holds to be outside human control? Our world, in thirty brief years, has already gone back to a barbarism that was unthinkable to all but a few bitter pessimists in the nineteenth century. I say

this, not to alarm you further and push you into more sinister Spenglerian conclusions, but to offer on this very basis a new hope: for if it can go backwards, through sin and error and deliberate malice, it can also go forward through more benign and constructive human efforts. We are not, in other words, prisoners of the machine; or if we are, we built the prison, we established the prison rules, *we* appointed ourselves the jailers: yes, we even condemned ourselves to a life-term within this grim place of confinement. But those prison walls are not eternal. So far from being given by nature, as the more pious believers in the machine have almost fooled themselves into believing, they are the outcome of the human imagination, concentrating upon one particular aspect of experience; and they can be broken down as fast as the walls of Jericho, as soon as the human spirit blows its horn and gives primacy, not to things but to persons.

The renewal of life is the great theme of our age, not the further dominance, in ever more frozen and compulsive forms, of the machine. And the first step for each of us is to seize the initiative and to recover our own capacity for living; to detach ourselves sufficiently from the daily routine to make ourselves self-respecting, self-governing, persons. In short, we must take *things* into our own hands. Before art on any great scale can redress the distortions of our lop-sided technics, we must put ourselves in the mood and frame of mind in which art becomes possible, as either creation or re-creation: above all, we must learn to pause, to be silent, to close our eyes and wait.

One of the truly original spirits of the nineteenth cen-

tury, a great logician, the Abbé Gratry, advocated as an
act of mental hygiene dedicating a half hour each day—
a half hour, no more—to complete retirement from the
world, not using it even to think quietly in, but clearing
one's spirit of all burdens and pressures, so that, as he
put it, God might speak to one, or, if you prefer to put
such matters in naturalistic terms, so one's hidden po-
tentialities, one's buried unconscious processes, would
have a chance to come to light. Now God does not speak
very often; but this act of detachment itself, even when
no visible results directly come from it, is one of the first
useful moves in reasserting the primacy of the person.
Mahatma Gandhi, who was a saint as well as an astute
politician, used to spend a whole day every week in com-
plete retirement and silence, and perhaps no man in his
time ever exerted so much influence over his contem-
poraries with so little visible apparatus to support him.

Once we have formed the habit of looking within,
listening to ourselves and responding to our own im-
pulses and feelings, we shall not let ourselves be so easily
the victims of uncontrollable emotions and affects: the
inner life, instead of being either a gaping void or a
ghoulish nightmare, will be open to cultivation and in
both personal conduct and in art will bring us into more
fruitful and loving relations with other men, whose hid-
den depths will flow, through the symbols of art, into
our own. At this point, we can nourish life again more in-
tensely from the outside, too, opening our minds to
every touch and sight and sound, instead of anesthetiz-
ing ourselves continually to much that goes on around
us, because it has become so meaningless, so unrelated
to our inner needs. With such self-discipline, we shall

in time control the tempo and the rhythm of our days: control the quantity of stimuli that impinge on us: control our attention, so that the things we do shall reflect our purposes and values, as human beings, not the extraneous purposes and values of the machine. At first, we shall make headway slowly and be perpetually frustrated, because our ways will be a challenge—not merely a challenge but an affront—to those of our community. But even our smallest negations and inhibitions will help to give back the initiative to the human spirit; and in time we shall be able to make more positive choices, not merely rejecting the irrelevant, the trivial, the repetitious, but affirming with new vigor all the significant goods of our age, because even when those goods come to us only with the aid of the machine, they will be ours to command: ours to reflect upon and to enjoy.

What I am saying here, in effect, is that the problems we have inquired into within the special realms of art and technics are illustrative of much larger situations within modern society; and that, therefore, we cannot solve these problems until we have achieved a philosophy that will be capable of re-orienting this society, displacing the machine and restoring man to the very center of the universe, as the interpreter and transformer of nature, as the creator of a significant and valuable life, which transcends both raw nature and his own original biological self. Man is not merely a creature of the here and now: he is a mirror of infinity and eternity. Through his own experience of life, through his arts and sciences and philosophies and religions, the brute world of nature rose to self-consciousness and life found a theme for existence other than endless organic trans-

formation and biological reproduction. When man ceases to create he ceases to live. Unless he constantly seeks to surpass his animal limitations, he sinks back into a creature lower than any other brute, for his suppressed creativity, at that moment, will possess with irrational violence all his animal functions. Since wholeness and balance are the very conditions for survival, no less than for creation and renewal, these concepts must take the place of a philosophy based on isolation, specialization, the displacement of the personal, the one-sided emphasis of the external and the mechanical.

Almost half a century ago, a very great human being, William James, gave a series of lectures here at Columbia, and in those lectures he attempted to bring together and reconcile the sundered halves of the modern personality: the empiricist and the idealist, the scientist and the man of religion, the fact-finder and the form-maker, or as William James put it, the tough-minded and the tender-minded. The lectures, which he published in the book called *Pragmatism*, did not succeed in pleasing any group particularly; and, indeed, it failed of its purpose to effect a true union, because James allied himself, on the whole, with the so-called tough-minded group, and wanted the privileges of tender-mindedness—the privilege of believing in ideals, values, the existence of God—only in a small province where certainty, or at least probability in the tough-minded sense, was beyond experimental demonstration. Much as I love William James, the man, much as I have learned from those great Emersonian flashes of his, which often transcend the limitations of his philosophy, I have long been critical of such a partial solution, such a one-sided synthesis. But where James' richly qualified

mind failed, it is certainly a little brash of me to hope that I might succeed, within the scope of half a dozen lectures, in giving you even the faint outline of a more comprehensive and adequate philosophy. Nevertheless, I felt that it was better to fail in making such a sketchy attempt, provided I honestly faced the concrete actualities of art and technics, than to succeed in presenting some narrower formula which would, at the end, leave the main problem unstated, as well as unsolved. One's last word is but a beginning.

So let me now sum up. Going back to the earliest forms of art and technics that anthropological research has turned up, I pointed out that man is both a symbol-maker and a toolmaker from the very outset, because he has a need both to express his inner life and to control his outer life. But the tool, once so responsive to man's will, has turned into an automaton; and at the present moment, the development of automatic organizations threatens to turn man himself into a mere passive tool. Fortunately, that does not mean either the end of art or the end of man. For the creative impulses that stirred in the human soul hundreds of thousands of years ago, when man's inquisitiveness and manipulativeness and growing intelligence and sensitivity caused him to throw off his animal lethargy—these deep impulses will not vanish because, temporarily, one side of his nature, that disciplined by tool and machine, has gotten out of hand. That is a momentary distortion of growth: and it is in the nature of life itself, after a period of growth, to seek to resume equilibrium, in order to be ready for the next act of growth. While life persists, it holds the possibility of circumventing its errors, of surmounting its misfortunes, of renewing its creativity.

We are now at a critical moment of history, a moment of great danger, but also of splendid promise. The burden of renewal lies heavily upon us; for there is no going on with the rigidities and compliances that have so far disintegrated our culture, without finally undermining the basis of life itself. The present curtailment of political and intellectual freedom in the United States, as the result of insidious changes that have taken place within the last decade, is only a symptom of a larger loss: the abdication of the human personality. Our acceptance of this curtailment with so little effective protest gives the measure of our moral collapse.

Yes: the burden of renewal lies upon us; so it behooves us to understand the forces making for renewal within our persons and within our culture, and to summon forth the plans and ideals that will impel us to purposeful action. If we awaken to our actual state, in full possession of our senses, instead of remaining drugged, sleepy, cravenly passive, as we now are, we shall reshape our life to a new pattern, aided by all the resources that art and technics now place in our hands. At that decisive point we shall perhaps lay the foundations for a united world, because we shall aim to join together, not merely the now hostile tribes and nationalities and peoples, but the equally warring and conflicting impulses in the human soul. If that happens, our dreams will again become benign and open to rational discipline; our arts will recover form, structure and meaning; our machines, however highly organized, will be responsive to the demands of life. And in the end, proudly reversing Blake's dictum, we shall, I hope, be able to say: *Art elevated, imagination affirmed, peace governs the nations.*